Controlled
Watercolor
Painting

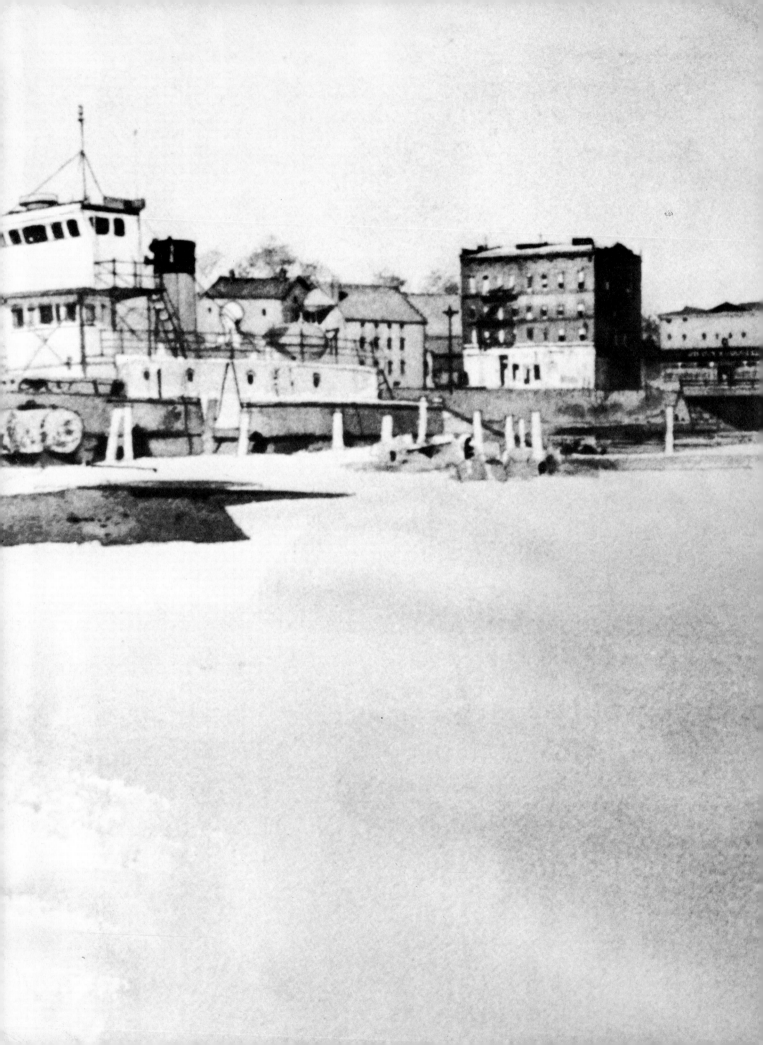

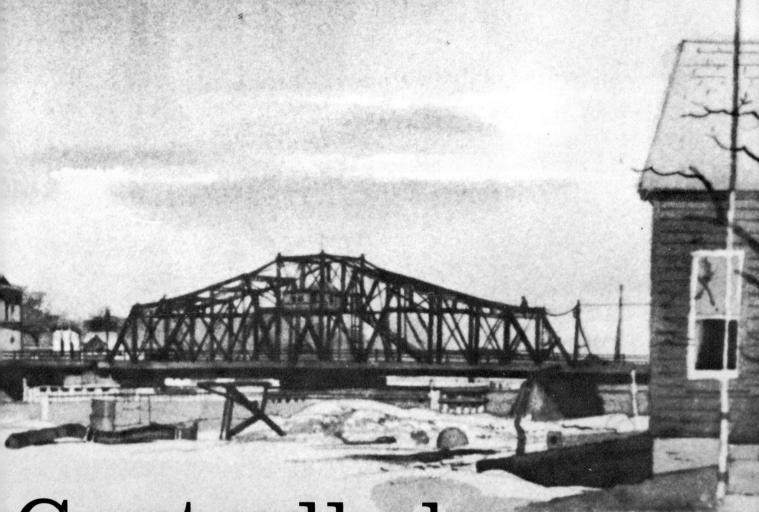

Controlled
Watercolor
Painting

by Leo Stoutsenberger

 NORTH LIGHT PUBLISHERS

Published by NORTH LIGHT PUBLISHERS, an
imprint of WRITER'S DIGEST BOOKS, 9933
Alliance Road, Cincinnati, Ohio 45242.

Manufactured in U.S.A.
First Printing 1981
Second Printing 1983

Library of Congress Cataloging in Publication Data

Stoutsenberger, Leo.
 Controlled watercolor painting.

 Bibliography: p.
 1. Water-color painting—Technique. I. Title
ND2430.S8 751.42'2 81-11260
ISBN 0-89134-035-1 AACR2
ISBN 0-89134-040-8 (pbk.)

Edited by Fritz Henning
Designed by Leo Stoutsenberger
Composition by P&M Typesetting

Acknowledgements

Appreciation for introducing me to watercolor is extended to Emily Steuart, my high school art teacher. It was she who first encouraged me to use the medium. Later on George Rarey inspired me to want to paint landscapes with pigment and water. Professor Deane Keller at Yale, who since my student days has been a great inspiration and friend. To Ed Paier for giving me the opportunity to teach techniques in his school and by so doing learn more about watercolor than I could ever absorb on my own.

The photography work for the book was ably done by David Wygant, to whom I owe much for his constant help. Many of the original color slides of my works were done by Bill Phelan and William Velmure, Jr. To them and to the Davenport Photo Labs in Hamden, Connecticut I extend my thanks.

To Fritz Henning and all the staff at North Light I bow in humble gratitude. It's been hard work mixed with occasional grief, but ending with a sense of relief and fulfillment.

For Dawn
and the five other women
in my life.

Contents

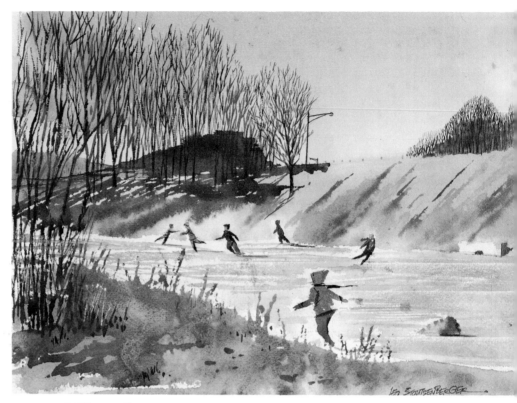

Branford Winter Sports

This painting is especially important to me because it represents the beginning of my interest in watercolor. Our three daughters were small, and before driving them to a local pond to skate one wintry afternoon, my wife Dawn urged me to take along my watercolor materials. The result was the above sketch. Painted on a 10" x 14" Arches watercolor block.

Foreword

Several years ago the publishers of North Light asked if I would consider doing a book on watercolor painting. "Not another watercolor book!" I responded. What was there to say that was new about a medium so admirably covered by Nechis, Brandt, Reid and a dozen other contemporary artists? Surely the approaches to aqua painting had been covered from A to Z.

In spite of my initial objections, I found myself thinking more and more about the special processes, techniques and problems pertaining to painting watercolors. As I tackled a new picture, I asked myself the kind of questions a beginner might ask. I tried to strip away nearly forty years of experience and think about each habit-forming maneuver and unconscious hand manipulation as if I were facing the problem for the first time. Also, when teaching my classes at Paier School of Art, I worked extra hard to find new ways of explaining the mechanics of picture making and the intricacies of creating a competent watercolor.

All these efforts produced the conclusion I *did* have something to add to the body of material already in existence on this exciting and perplexing subject. My ways of working and solving problems are different than the procedures others have developed. They may not be the best and they may not work for everyone, but they work for me. If, in glancing at the examples shown in this book, you like my kind of painting, I believe I can offer you some advice and suggestions not found elsewhere.

world. To get close to nature and still survive in comfort, some stalwarts have built intricate shelters to protect themselves from the torments of wind, cold and insects. Winslow Homer, for instance, had a small structure not too much bigger than a phone booth built on tracks which allowed him to paint closer to the frigid, wind-torn waves of the coast of Maine than would otherwise have been possible. Others have similar devices to afford them shelter while communing with an inhospitable environment. Not to be outdone, I too have contrived a method of coping with the elements.

The universal familiarity of my contrivance makes me wonder why my procedure is not in more common use. Simply, my portable studio is my car. It will transport me almost anywhere I want to paint; it offers a shelter, some warmth and sufficient working area for watercolor painting once you realize how little space is necessary to paint a picture.

Many painters prefer to work in a warm, comfortable studio. But a certain amount of discomfort helps my creative process. Besides, I am constantly interrupted when working in the studio. So, to me, the isolation of the car, with two or three hours of complete and uninterrupted concentration makes an ideal working arrangement. Of course, you can have it both ways. Work in the car on location, using a half sheet of your watercolor paper. Then return to your studio and project it up to a full sheet.

Of one thing I am certain: all artists should think about producing a book as they go about doing a picture. Few exercises will clarify your thinking about drawing and painting more sharply. Never mind whether or not you find a publisher. The process of writing and thinking through the things you do will be a rewarding effort. Chances are your work will improve and you'll see your working procedure in a new light. Certainly my effort

has provided me with many hours of helpful searching. And it has enriched my painting experience through the analysis of the possible ways of helping others broaden their awareness.

Every artist comes to know that drawing directly from nature is the best teacher. From Leonardo to Cézanne and beyond, the notes and letters of great artists speak with glowing gratitude of the truth and beauty offered only by the real

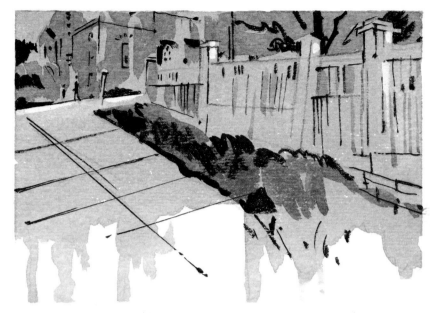

Most of the things we do well are the result of regularly working at it. This is important if you wish to perfect your watercolor technique. Try to establish a habit of going out once a week to paint. If possible, increase this to twice a week, and if you can arrange it later on, three times a week. It's easier to sustain enthusiasm about your work when you paint on a regular basis. There's an old maxim that says you can't call yourself a watercolorist until you've painted a thousand pictures.

All of the material in these pages is based on direct study and observation of the subject. Branford, the town where I live, is a small New England community with many interesting painting subjects. However, there's nothing more special about it than almost any other American town. You have to seek out subjects worthy of painting. But the more you search, the easier it becomes. Subjects I saw a few years ago and didn't think suitable for painting have since become favorite haunts. Sometimes I draw and paint one subject eight or nine times. But each painting will be different. You'll find several examples of this as you progress through these pages.

Avoid slavishly copying the subject, even though some satisfaction might be derived from learning to copy with accuracy. Barbara Nechis has a commendable approach to painting. She turns her back to the subject, referring to it only when she needs to. Robert Henri employed a like procedure. In *The Art Spirit* he tells of teaching a life class by having the model posing in one room and the students drawing and painting in another. Even though you may prefer to work more directly from the subject, I recommend this approach as it helps you really *see* and observe when you are *looking* at your subject.

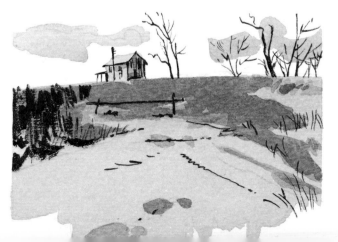

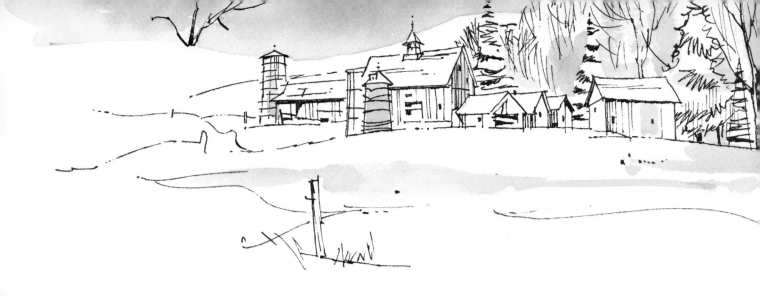

Introduction

Landscape painting in watercolor gives me an opportunity to escape the realities of the day-to-day routine. Sitting alone on a forsaken beach on a Sunday morning in the car listening to the silence can be tremendously therapeutic. Add to this the personal satisfaction of actively doing something about the exciting poetic images changing and taking place in front of you. Painting a picture can be wonderfully stimulating.

When you bring the result of your experience home and invite comments about it from your roommate, your spouse, family or friends, you have tangible evidence of your observation and experience. There on your terrace or in the kitchen you can have your own critique, and this part of the painting experience can be important. After each attempt, you should try to pull the painting apart piece by piece and consider how you might improve the composition, the color, or the overall design.

Many beginners concern themselves prematurely with acquiring an individual style or technique. The manner of painting that's right for you and your own distinctive style will develop as

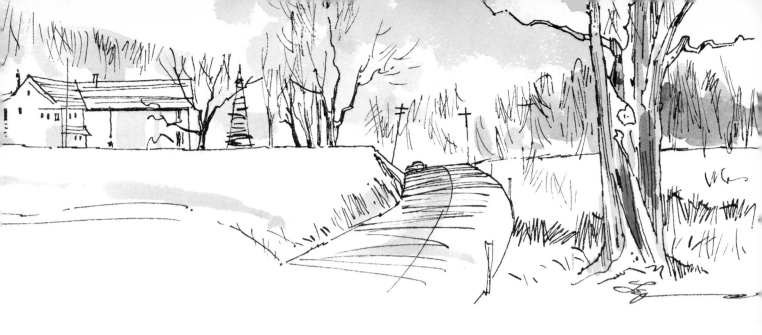

you become more experienced. It's easy to be tempted to give up. People often tell me they would have loved to become artists. While in grade school or beyond, they did wonderful things with pencil and paint. When I ask, "Why didn't you continue with your art work?" the reply usually has to do with the pressures of making a living and the need to provide for a family. In fact, it is never too late to begin again to take up where you left off. There are many examples of people who benefited from this approach. Eliot O'Hara, one of our best known watercolorists, didn't begin serious painting until after he'd retired as a successful businessman. And Frederic Whitaker, though an established artist, did not turn to watercolor until he was in his sixties.

Creativity is a strong force within all of us. Neither this book nor any other book can teach creativity. But I hope it will inspire you to go out and look at nature with a broader concept. As Ward Brackett observed: "To draw as one imagines, one must first learn to draw as one sees."*

* *When You Paint* published by North Light.

CHAPTER 1
Before you paint

Drawing is the framework or skeleton upon which the painting flies or falls. If you want to be a better watercolorist, the first step is to improve your drawing. How do you do this? By drawing, drawing, and more drawing.

What holds the creative imagination back, as Robert Fawcett once put it, is "sloppy seeing." We must *see* first, then we may safely imagine more; vagueness and blurred seeing are not the same as inspired transformation of reality. There are some who contend that a disciplined study of drawing is outmoded, and that the modern artist develops somehow by himself and without formal training. The vague and indefinite scribbles of the beginner are too often touted as rare flashes of genius which will always be denied the patient searcher. We're living in an age when graffiti is sometimes looked upon as being an art form. And the ability to draw well, we are told, is something to be unlearned. Don't you believe it!

The keen eye, which looks in wonder and appreciation at the way things are, soon develops the humility which precedes the gaining of knowledge.

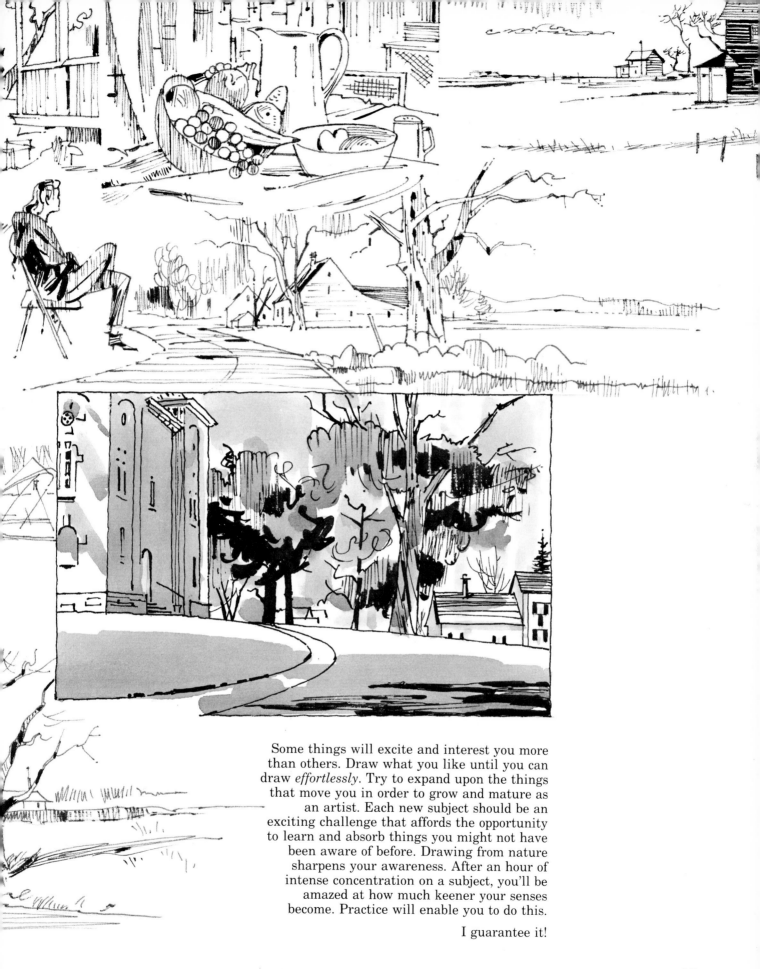

Some things will excite and interest you more than others. Draw what you like until you can draw *effortlessly*. Try to expand upon the things that move you in order to grow and mature as an artist. Each new subject should be an exciting challenge that affords the opportunity to learn and absorb things you might not have been aware of before. Drawing from nature sharpens your awareness. After an hour of intense concentration on a subject, you'll be amazed at how much keener your senses become. Practice will enable you to do this.

I guarantee it!

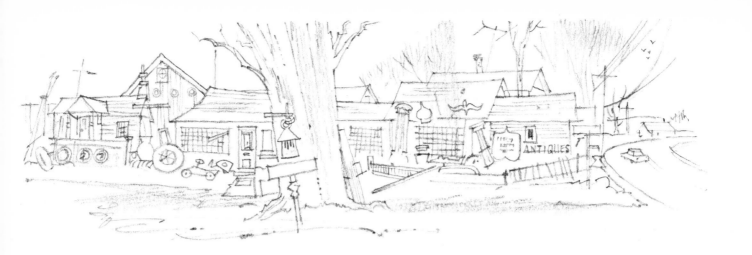

Drawing the subject

A line can be produced with many different implements. The pencil is one of the oldest. Most students feel relatively comfortable using this graphite tool. However, if you want to break out of a mold of old habits, try using other materials. On your next painting trip take along a bottle of ink and a brush. Try drawing the subject directly in ink. Another time try some black watercolor pigment and a brush. Mix light and dark washes and see your subject in values without color. Remember, whatever the tool, *draw* with it!

The felt tip pen is fast and it's a versatile drawing implement. You should realize, though, it is not permanent. The ink used in these pens is apt to fade if it has much exposure to light. Experiment! You'll find the kind you like best and what works best for you.

The drawing "Leete's Farm", reproduced below, was drawn direct from the subject using a No. 2, series 7 Winsor & Newton sable brush with black India drawing ink. Notice the versatility of the brush in creating a great variety of thick and thin lines.

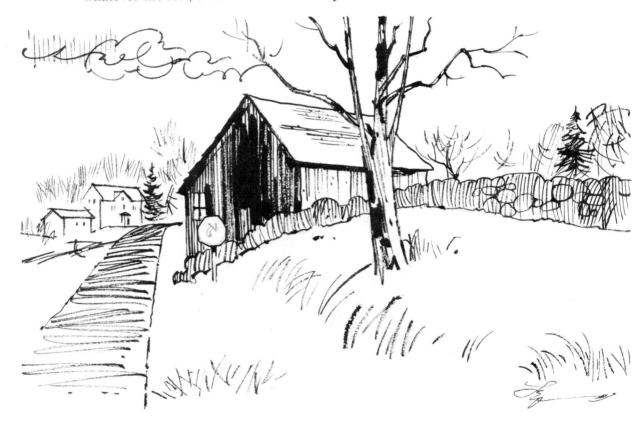

Stony Creek Lobster Shack

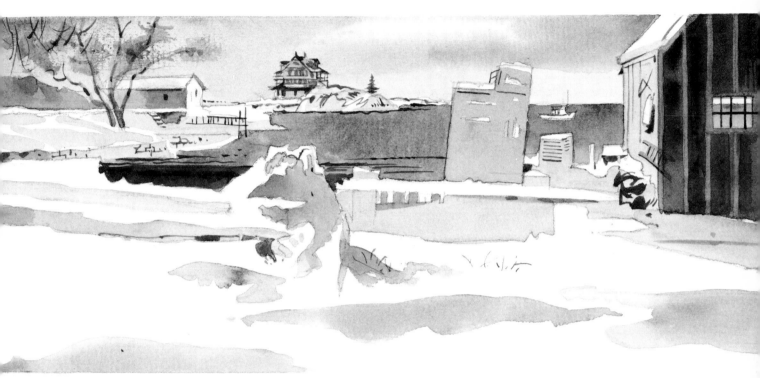

This subject was first carried out as a full color painting. Although the original was sold, I later decided to paint it over, based on a slide I had kept. This time I used wash (lamp black pigment and water), and had it printed as a Christmas card. The patterns of shadow in the snow together with the sharp, dark accents make an appealing subject in any medium.

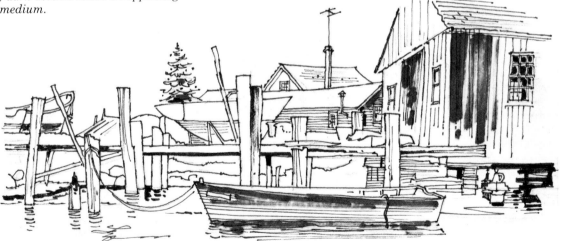

Drawn directly from the subject, using a felt tip pen, I tried to make the softness of the marker line describe the intricacies of detail to be found in the accumulation of interesting shapes and textures.

Christmas at Tyler's Boat Yard

17

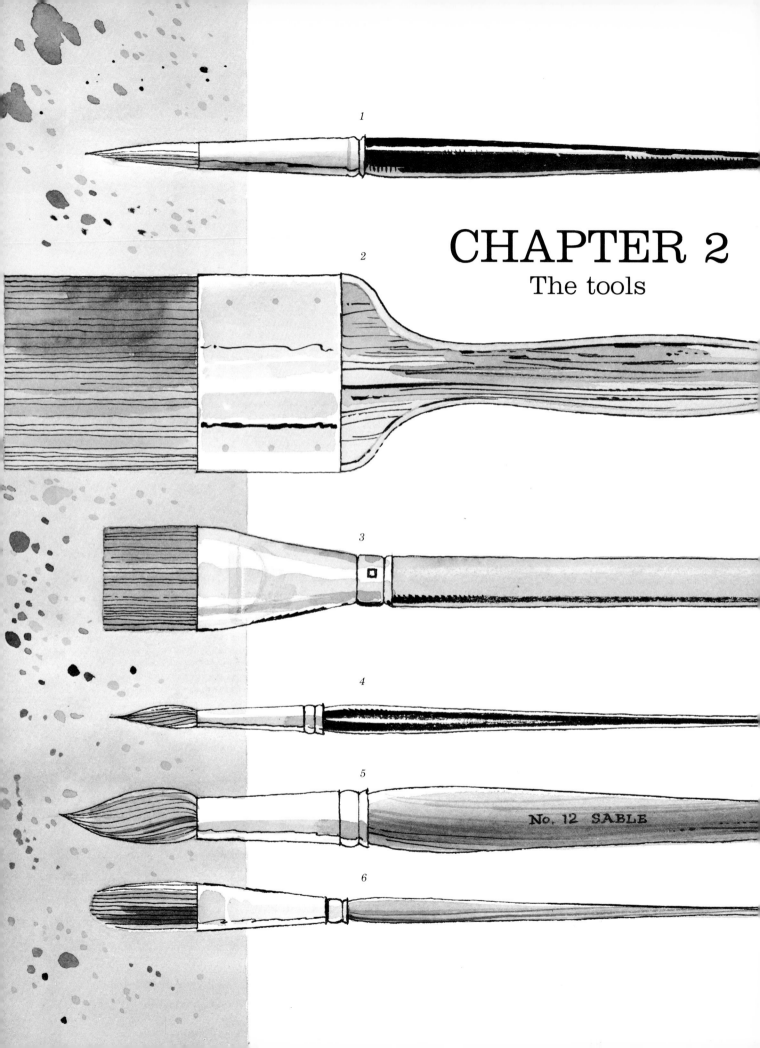

CHAPTER 2
The tools

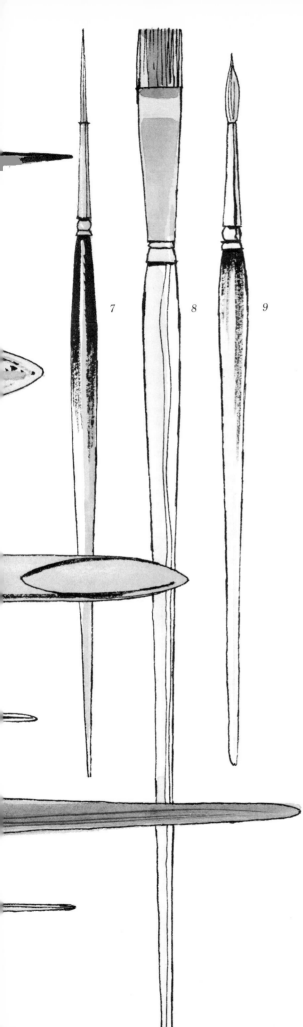

7 8 9

Brushes: The sizes and types of brushes illustrated here have served me well over the years. These drawings are reproduced the same size as the actual brushes. This assortment works well for me—with experience you'll decide what types work best for you.

Each brush has a special function. To find the best quality, you must test them and practice with them until you know exactly what they can and cannot do. Within a reasonable time, you will be able to use them as naturally as you drive your car.

1 A practical brush, and the one I probably use the most. Notice the unusual way the bristles taper. This is not a sable, but a cheaper bristle called ox hair.

2 For large washes, usually wet-in-wet, this is a marvelous brush. It enables you to apply a smooth wash without those ugly edges that might result when using a smaller brush. Made by Grumbacher, 2 inches wide, the bristles are ox hair.

3 The 1-inch Aquarelle is a fine brush. I don't use the sable model. The cheaper one with Erminette bristles and a green plastic handle works well for me.

4 This is your standard top grade sable in a No. 8 size. Most details can be handled easily with this model.

5 A No. 12 sable brush is one you'll have to mortgage the house to buy. Usually you can paint most pictures without it. Although useful, don't rush out and buy one until you feel you really need it.

6 In most art supply catalogs this is called a rounded flat or an oval shape. It is also referred to as a Filbert. For certain textures it is a valuable tool.

7 The No. 3 rigger is an indispensable brush. The line it produces can be sheer poetry. Every watercolorist should have this brush and learn to use it well.

8 The old hog bristle oil painting brush is one that I use for taking out washes and for special effects.

9 The No. 2, series 7 Winsor & Newton sable is a premier quality watercolor brush. Its versatility is outstanding. For me, this brush requires a little more T.L.C. than the other brushes.

19

Your portable studio

The equipment illustrated here suggests most of the items that make up my portable studio. Almost all of them fit conveniently into the canvas bag indicated at the lower left. You can have such a totebag made to your own specifications or you can buy one in most hardware or department stores. The other items are: towel or absorbent cloth; water bowl (mine is usually a cleaned out yogurt or cottage cheese container) a used plastic soap bottle for clean water; metal box for tubes of paint; palette and brush box; T-square, drawing board and triangle (helpful when drawing buildings); tissues, mist sprayer and masking tape complete my inclement weather kit.

If it's summertime, and you are not going to sit in the car but under a shade tree, then you would want to add to these items a small folding camp stool. The mist sprayer, the masking tape, tissues, triangle, and T-square are items you can get along without on many sketching trips.

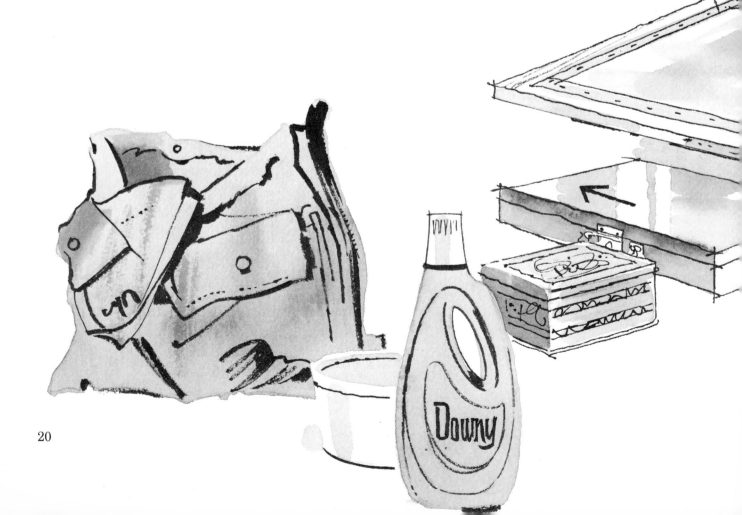

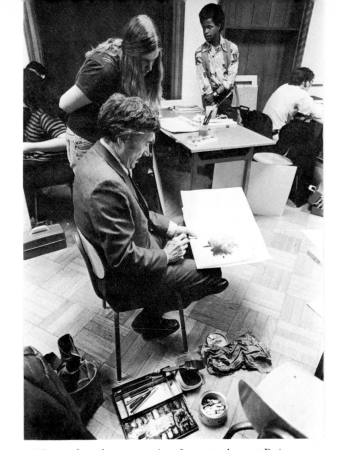

The author demonstrating for a student at Paier College of Art.

Photo by Richard Suarez

In packing my gear for painting, I find myself adhering to the rules of the camper. Keep your items down to a bare minimum. I once painted with a watercolorist who would take with him every kind of painting gadget imaginable. He was also a tag sale freak. Whenever he'd go to a tag sale he'd find another kind of fancy box in which to store shading stumps, or pen points, or thumb tacks, or a dozen other items. When he went out on a painting trip he was loaded with useless things. Not surprisingly, this individual seldom painted successful outdoor landscapes.

For me, one of the fascinating aspects of painting out of a bag is that I am ready to pick up my gear and go on a moment's notice. Even in a classroom my kit proves useful. As a teacher it allows me to take my "studio" from student to student and do mini demonstrations relating directly to the student's problems. A palette is a personal thing, and I'd rather not work with someone else's colors.

With the high cost of paint it is understandable why almost everyone has a tendency to use pigment sparingly. This is not good. Not having sufficient paint squeezed out on your palette is likely to inhibit proficient painting. With experience you'll discover how much pigment you should squeeze out for your type of rendering. Until you reach that stage it is better for you to err on the side of *too much* rather than too little.

The O'Hara Box

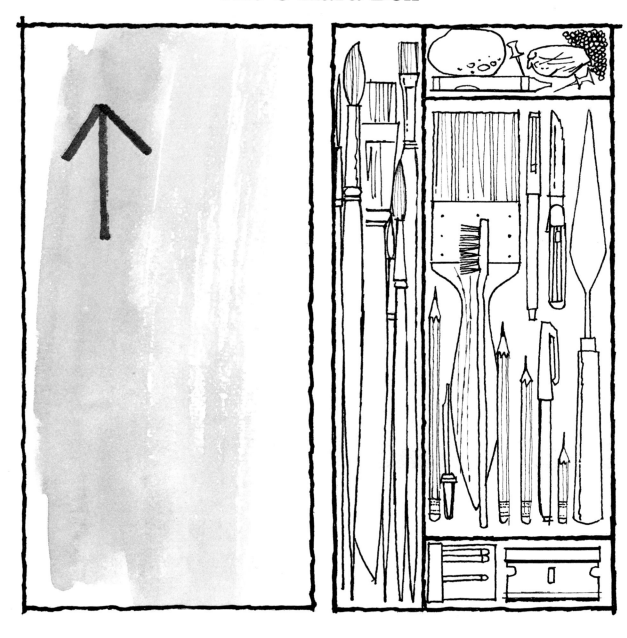

Eliot O'Hara was a classic watercolorist. Besides contributing many paintings and several good books on the subject, he designed a fine palette box. In the early forties I had one of the original boxes. It was painted with black enamel and held the separate palette in the lid of the box. Although the box was slightly smaller than the newer, modern version, it seemed large enough at the time. In fairness to Grumbacher, who

manufactures and markets the present version, it's a better box than the original one.

This excellent $6\frac{1}{4}'' \times 12\frac{1}{8}'' \times 1\frac{3}{4}''$ inch box can be purchased in most art supply stores. It has room for about eight brushes, normally enough for painting on the half sheet sized paper. The other compartments accommodate pencils, erasers, and any other miscellaneous items you might feel the need for.

There are 22 divisions on the palette. Most painters do not use so many colors on a single painting. Nevertheless, it's good to have some extra spaces for new colors you might want to try. The space down the middle is enough for mixing. However, some painters prefer to have a larger area to mix their washes. There's nothing wrong with taking along an extra mixing palette. A round china dinner plate is good for this purpose.

The black arrow on the outside of the lid was drawn with a marker to show the position the brushes lie in the box and reminds me to store the box in my bag with the arrow pointing up. This helps to keep the points of the brushes from being damaged.

Pigments

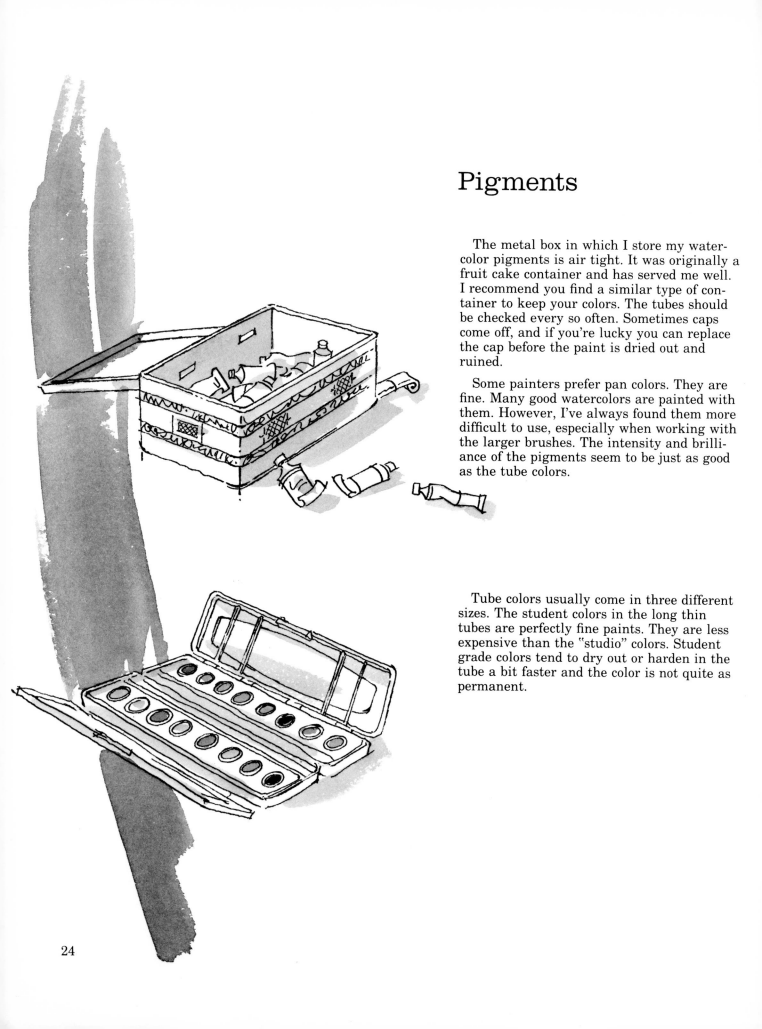

The metal box in which I store my water-color pigments is air tight. It was originally a fruit cake container and has served me well. I recommend you find a similar type of container to keep your colors. The tubes should be checked every so often. Sometimes caps come off, and if you're lucky you can replace the cap before the paint is dried out and ruined.

Some painters prefer pan colors. They are fine. Many good watercolors are painted with them. However, I've always found them more difficult to use, especially when working with the larger brushes. The intensity and brilliance of the pigments seem to be just as good as the tube colors.

Tube colors usually come in three different sizes. The student colors in the long thin tubes are perfectly fine paints. They are less expensive than the "studio" colors. Student grade colors tend to dry out or harden in the tube a bit faster and the color is not quite as permanent.

The smallest of the three tubes pictured at the right represents the professional or studio category of watercolor pigment. Most of the manufacturers adhere to this size relationship in packaging their colors. All tubes of student colors sell for one price. However, the professional colors are divided into different series according to the color. If you buy an earth color such as burnt sienna you'll pay less than if you buy a tube of cobalt blue. The same size tube of cadmium red or cadmium yellow will cost more than the cobalt blue. And if you buy vermilion (which I don't use) it'll cost you even more.

The largest tube represents the professional category of paint but supplied in a larger quantity. As you paint, you'll find that there are one or two or three colors that you use more than any of the others. When this happens it makes sense to buy the larger tube. Proportionally they cost less.

Pigment sometimes gets into the threads of the cap and hardens, causing the cap to be glued shut. The best way to free stuck caps is to hold a burning match under the cap while slowly turning the tube. If the cap resists all attempts to remove it, the tube may be unrolled and opened from the bottom end. This tends to be messy, so exercise care when following this procedure.

Choosing the
right paper
or board

Most paper and board used for watercolor is available in three broad groups: smooth, medium and rough. Usually the smooth is referred to as "hot press," the rough is called "cold press," and the medium surface depends pretty much upon what brand you are buying.

Obviously, beginners are well advised to use the cheaper grades of paper. However, the quality should be good enough to serve the special properties of the medium. Two of the less expensive kinds available in most communities are Morilla and Watchung. Of the two I prefer the Watchung. It has a rougher surface allowing the running of nice, even washes.

One problem which arises with using the Watchung paper and others of this type is the slick surface. Although the texture of the paper is rough, the sizing used in the manufacturing of the paper causes a slight repelling of the water. Either wetting the entire surface, or stretching the paper should overcome this difficulty.

Illustration board is available in a wide assortment of surfaces and two weights: medium and heavy. Some people feel more comfortable using this material because of its rigidity. It's actually a thin watercolor paper mounted to a cheap, rather pulpy cardboard. Although you do not have a buckling problem when working on "board" it has a tendency to curl when the surface is wet.

The finest paper that I've ever used is a handmade paper imported from France called Arches. This paper comes in hot press, which is quite smooth, cold press, which is fairly rough, and a third category which the company calls rough—a rougher surface than their cold press finish.

The weight or thickness of watercolor paper is usually defined as 70 pound, 140 pound, or 300 pound designations. If you prefer stretching your paper you'll probably prefer buying the 140 pound type. The 300 pound paper is so heavy it is seldom necessary to stretch it.

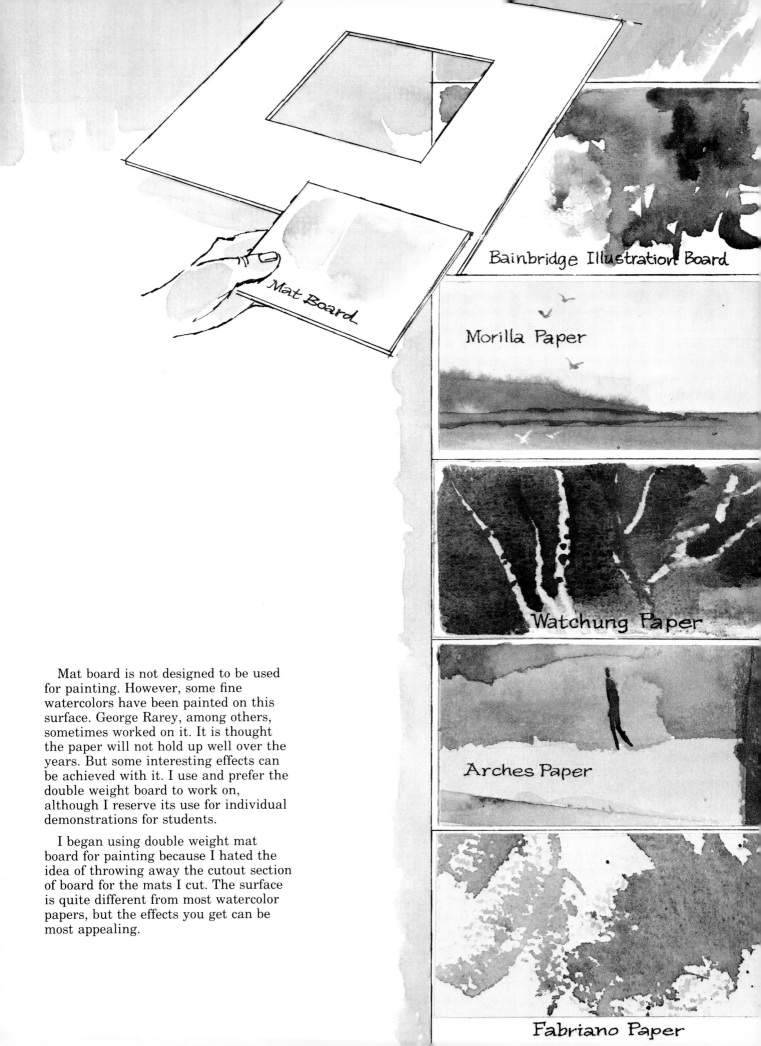

Bainbridge Illustration Board

Morilla Paper

Watchung Paper

Arches Paper

Fabriano Paper

Mat Board

Mat board is not designed to be used for painting. However, some fine watercolors have been painted on this surface. George Rarey, among others, sometimes worked on it. It is thought the paper will not hold up well over the years. But some interesting effects can be achieved with it. I use and prefer the double weight board to work on, although I reserve its use for individual demonstrations for students.

I began using double weight mat board for painting because I hated the idea of throwing away the cutout section of board for the mats I cut. The surface is quite different from most watercolor papers, but the effects you get can be most appealing.

Blocks and pads

Painting papers are available in a number of different forms. Blocks are probably the most popular type of watercolor pad. It is simply a stack (usually 24 sheets) of paper, glued around all four sides on the paper. The sheets are stacked on a heavy piece of cardboard to give the block stability. On one of the four sides will be an opening into which a knife blade may be inserted. After you have painted your watercolor you insert a knife blade into this opening and carefully cut all the way around the four sides until you free the top sheet. To avoid cutting the papers' surfaces it is best to use a dull blade.

The block works fine for the first dozen watercolors or so, but after this, the water running off the edges of the paper may disolve some of the side glue. Then the paper can come up at various points along the edges. This may not bother you when you paint. If it does blocks are probably not a good solution for your paper problem. They usually cause me trouble and the only times I use watercolor blocks are when I go away on a trip and don't want to stretch my paper.

The spiral sketch pad is fine for sketching or practicing washes. However, they are not practical for painting finished watercolors. Markers, pencil, brush and ink, pens with colored ink, all work fine on sketch pads.

Book bound sketching pages are available and useful. Some artists like to keep their sketches like this so they can store them in the bookcase.

CHAPTER 3

The four ways of applying watercolor to paper

Skill as a watercolorist depends in a large measure on how well you can perform the following procedures:

1 Dip your brush into water, load it with some pigment and apply the mixture directly to the paper using horizontal strokes. I refer to this as *dry wash*.

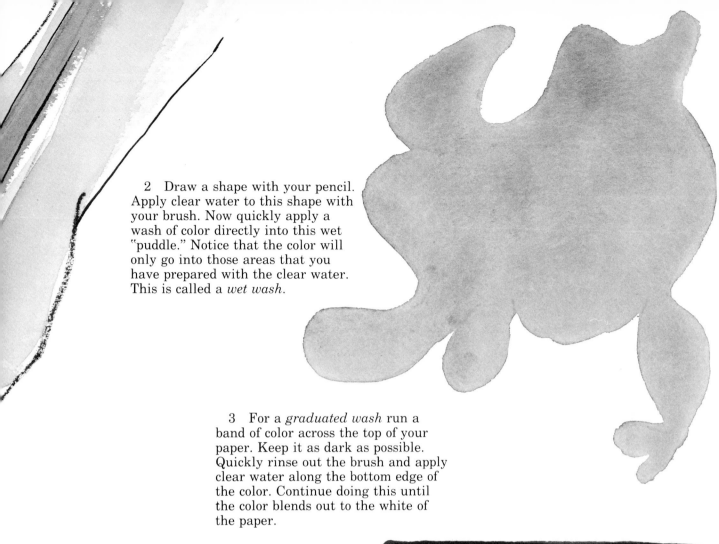

2 Draw a shape with your pencil. Apply clear water to this shape with your brush. Now quickly apply a wash of color directly into this wet "puddle." Notice that the color will only go into those areas that you have prepared with the clear water. This is called a *wet wash*.

3 For a *graduated wash* run a band of color across the top of your paper. Keep it as dark as possible. Quickly rinse out the brush and apply clear water along the bottom edge of the color. Continue doing this until the color blends out to the white of the paper.

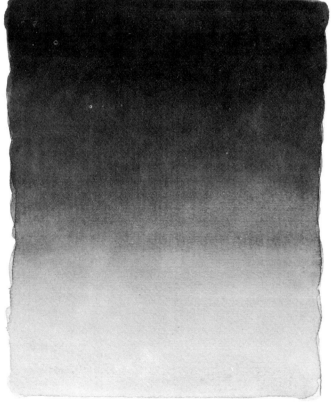

4 *Dry brush* technique should be used sparingly. To produce the effect, pick up color with a little water on your brush. Now wipe most of the color off the brush on your towel. Next apply some strokes to the surface of your paper, manipulating the brush to simulate the material or texture you're representing.

31

In this painting your attention is called to the four categories demonstrated on the preceding two pages. (1) Indicates areas where dry brush is shown twice: the roof and the trees on the right. These being small shapes, the application of direct, dry washes was appropriate.

The wet wash (2) is shown in these two instances because the areas are large and it was important to keep the shapes free of brush strokes.

The sky (3) demonstrates the gradation of wash from dark to light.

In (4) the dry brush has been used with restraint. The diagonal shadows on the house, the foliage in the trees and the areas of the grass all show applications of this technique.

All the washes in this painting were done to create interesting variations of textures, values and shapes. They were not thought of just as washes filling in areas.

Autumn on Route 1

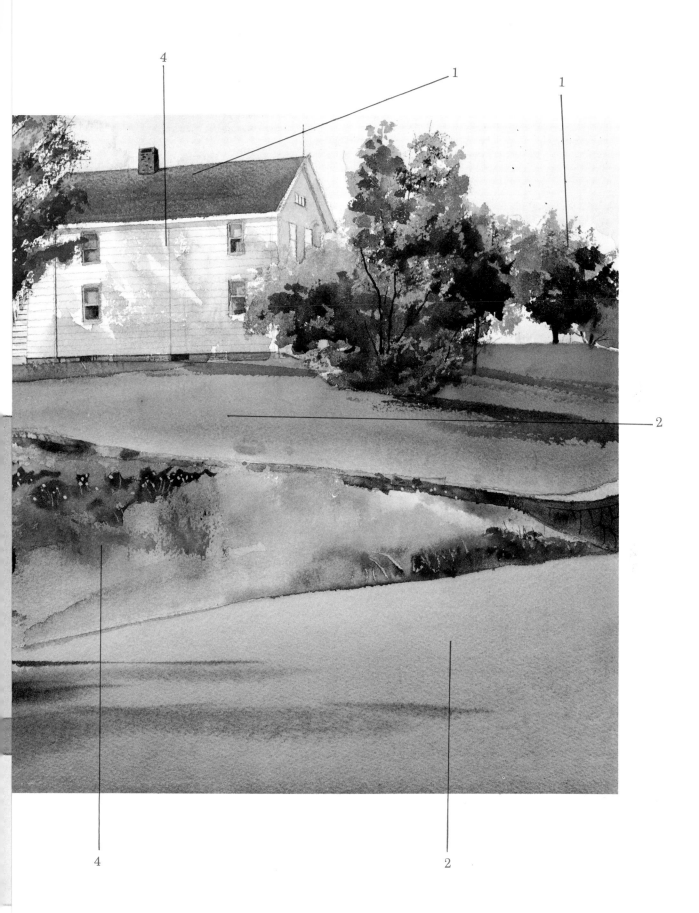

Draw,
paint, draw, paint,
draw, paint

This method is not new. I adapted it to my working procedure after I encountered some unhappy experiences where the graphite of the pencil mixed and dirtied the washes of color. The procedure usually isn't followed as methodically as shown here. But practicing these steps of drawing and painting can improve your picture making potential tremendously.

1 **Draw** the four shapes that represent the areas where the Number 1 values are located.

2 **Paint** the first wash. This is a light value comparable to the Number 2 in the value scale.

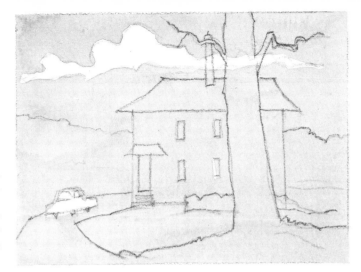

3 **Draw** the main
parts of the composition
in pencil. Keep it simple.
Notice that there are no
shadows or
embellishments
indicated.

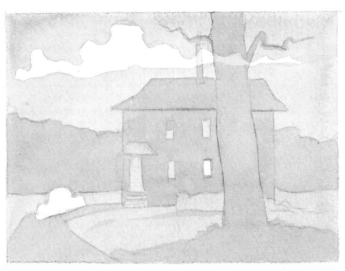

4 **Paint** the Number
2 gray in the planned areas.

5 **Draw** the pine tree
on right and the figure.

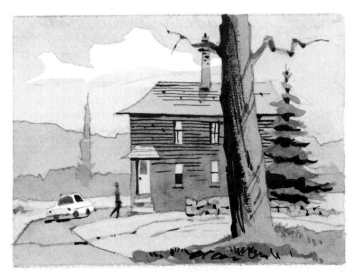

6 **Paint** darkest
washes to complete
painting.

CHAPTER 4
Now you can take your studio to the painting site

In cold weather, a light warm jacket, your tote bag filled with materials and the stretched paper under your arm are all you need for a morning of watercolor pleasure. The front seats of most cars are large enough, once you get used to working in a limited space.

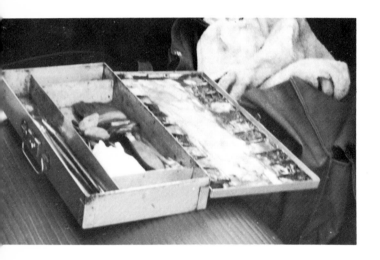

The open palette box and container of water fit easily on the car seat beside you. Notice the towel spread out under the board where it's convenient for catching surplus water and for wiping excess paint and water from your brush.

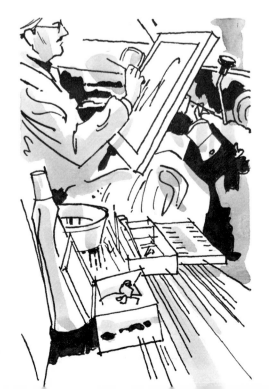

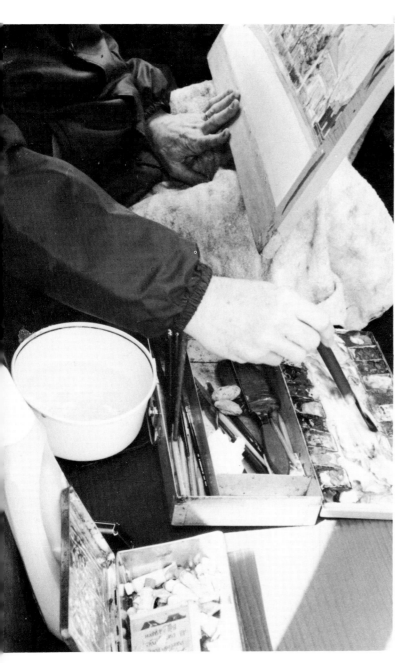

With the car seat adjusted back as far as it will go, there's ample room. The board rests on the steering wheel, the towel is spread on the lap for easy access, the water container, paint box, and palette box are within easy reach.

But isn't it easier to work from a photograph?

This is an often-asked question. My answer usually is "Yes, but think of all the fun you miss out on." Of course it goes much further than that. There are many reasons for going directly to nature to draw and paint. During the time you are working, the light changes several times, which usually creates problems for the beginner. But after a while you learn to cope with fickle light and make it work for you, not against you. Also, learn patience. While waiting for the light to return to the way it was you might see an object in the shadows not visible before. It may well serve as the focal center adding excitement to your picture.

Working from nature sharpens your awareness of things. Often I've found after working from a subject for an hour or so I stop and glance behind me at something I hadn't considered as fit to paint earlier. Suddenly it takes on new splendor and becomes desirable to paint. Often it'll become my next painting subject. I believe this happens because during the time you're looking at the one subject and drawing and painting it, your senses become so keen, so much more acute, that you see things you missed before.

If you decide to try my working methods, don't stay too long the first day. Allow yourself enough time. It'll take a few trips to become adjusted to the new working conditions. After a few sessions you'll feel quite at home in your front seat studio.

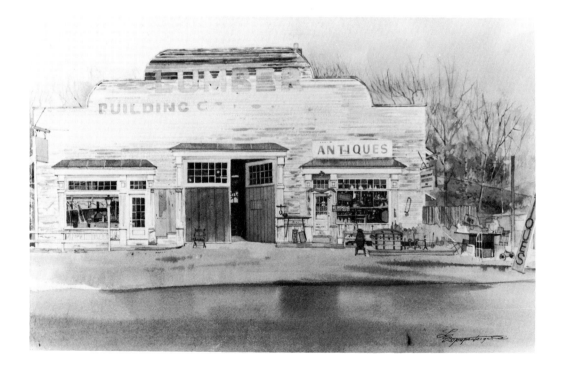

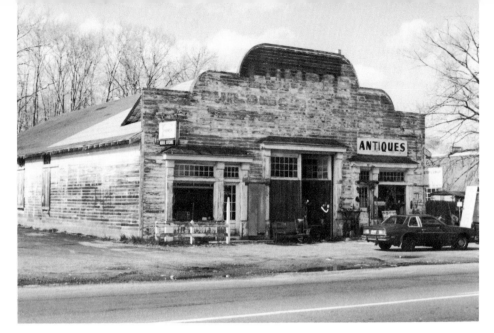

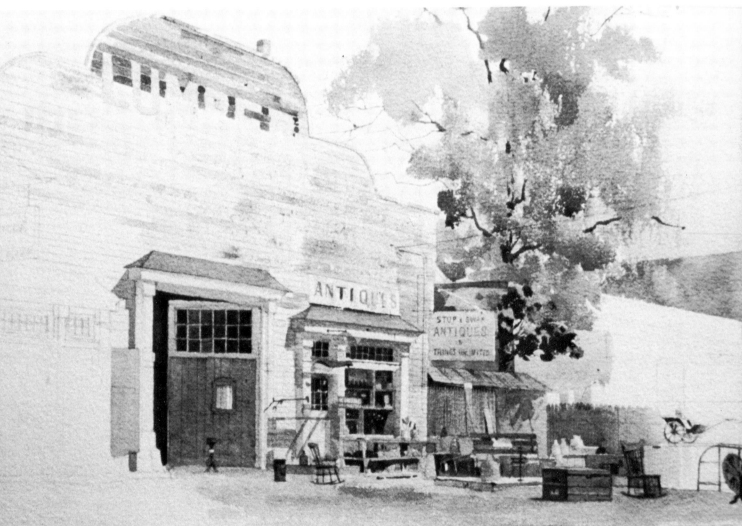

Stop and Swap
Collection: Mary Ann Doughan

Dealing
with the sun

Landscape painters used to take large umbrellas with them to keep the direct sunlight off their paper. Although you are not often faced with the same problem when working in your car, you may at times have some trouble with a low-angle sun. It can be annoying and a hazard to good painting. A large sheet of corrugated cardboard wedged into place at the window nearest to the sun usually solves the problem for me.

Sun glasses can help, although I do not use them. My glasses are the kind that take on a slightly darker tint when worn in the sun. Some artists feel that sun glasses distort the color enough to rule out their use. I don't go along with this because the values should be a greater concern than exactness of color.

My corrugated sun shield can be quickly placed against the rear window. You might have to cut your cardboard to fit the size of your car's windows. After finishing your painting don't forget to remove your shield!

The nickel-plated ferrules housing the bristles for most watercolor brushes are highly reflective. When the sun strikes this surface it's comparable to the blinding effect of a mirror when in direct contact with the sun's rays. You know how disturbing this can be! To solve this problem I wrap the ferrule of the brush with masking tape.

Here the cardboard is wedged in beside the painter. Passersby are usually perplexed by the effect, but if it keeps the sun off your paper it's worth the possible embarrassment.

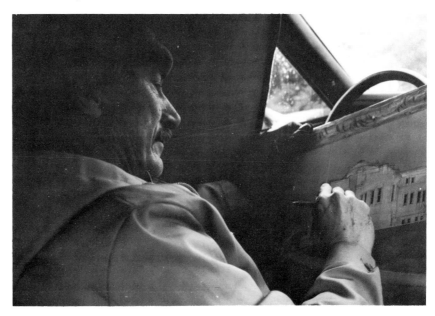

Composing the subject

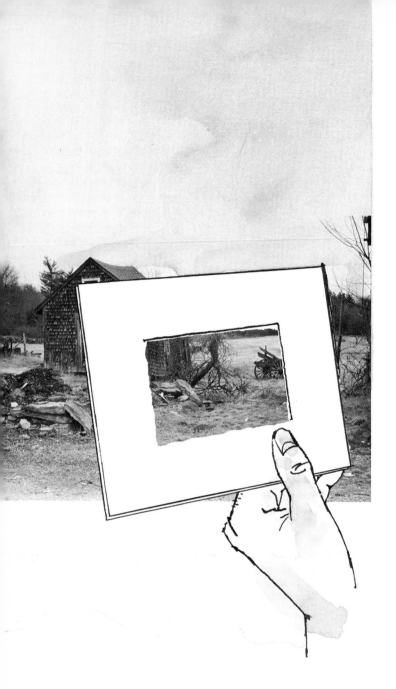

Composition as it applies to painting and drawing simply means the arrangement of shapes and colors in a way to please the eye. Most pictures that endure are based on good design. For this reason the search for good compositions can start with serious study of some of the Old Masters. A trip to a good municipal art gallery or museum every so often can go a long way in improving your ability to compose.

As landscape painters we must condition ourselves to leave things out. Nature is seldom if ever selective. To edit with skill and taste requires practice. After repeated efforts you'll be able to bring some kind of order out of the confusion that usually exists in nature.

A helpful device to use when you're starting out is a view finder. This is a piece of cardboard with a small rectangular opening cut into it. If you take this with you, it should help you find the composition in nature that appeals to you. After you've used this for a while, you can throw it away because by then you will have acquired an automatic view finder in your brain.

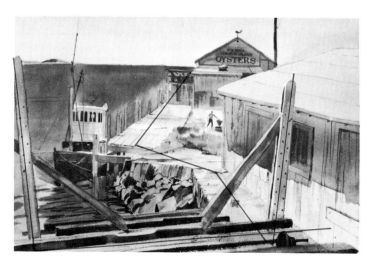

The example on the left is a study emphasizing the use of diagonals. Notice how the horizon stabilizes the composition.

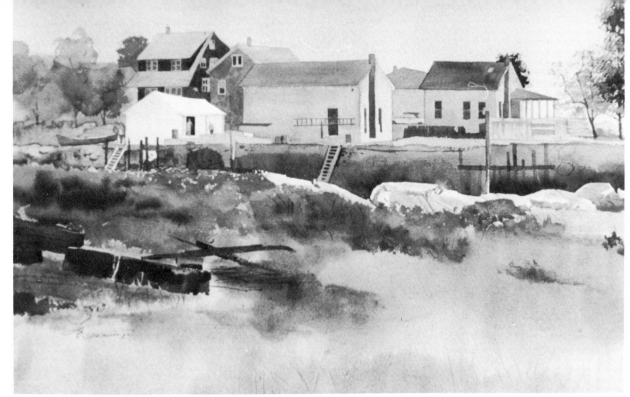

Tyler's Boatyard

The compositional trick here was to make the little boat house at the left the focal center by keeping it lighter in value than the surrounding buildings. Otherwise the scene was painted just as I saw it through my built in view finder.

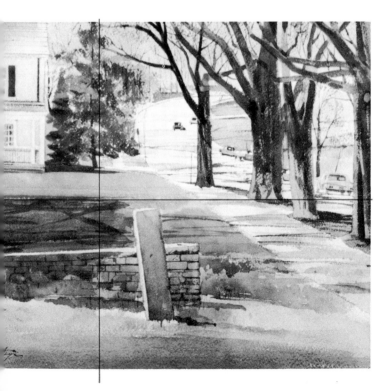

This painting was sketched on South Main Street in Branford. The title came about because the person who bought the picture came up to it at an exhibition and said with emotion, "My husband was born in that house, in the room behind that window." As it checked out, the lady was right.

I was drawn to the subject because of the old concrete post or monument overlapping the stone wall, the row of trees on the right complementing the lone tree at the left. The curve of the street breaks in from the right to counter the architectural lines of the house. The red line divides the picture into four parts to emphasize the position of the window in relation to the other parts of the picture.

45

Yellow House on Montowese

This diagram accents the way the dark shape on the left and across the bottom of the picture helps to give the composition a natural frame.

The subject was painted on a cold day in February when the sun was rather low, even though it was eleven o'clock in the morning. The figure was added for scale and also as a diversion. The house itself is really what appealed to me as a subject, with its carpenter gothic pillars and the ornate woodwork rising to the peak of the roof. I love painting subjects like this. When I find these old houses I understand how Edward Hopper must have felt. He practically made a career of painting subject matter of this sort.

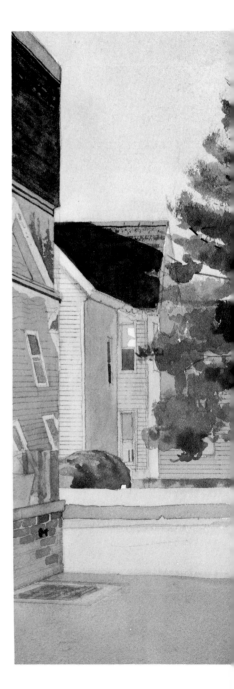

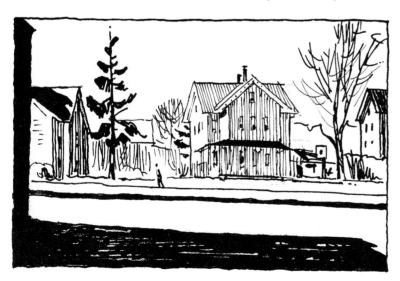

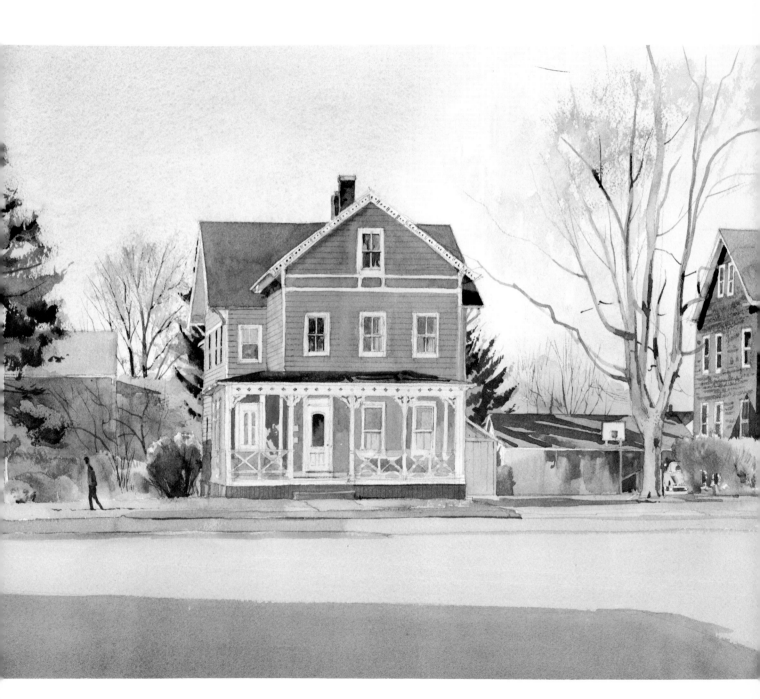

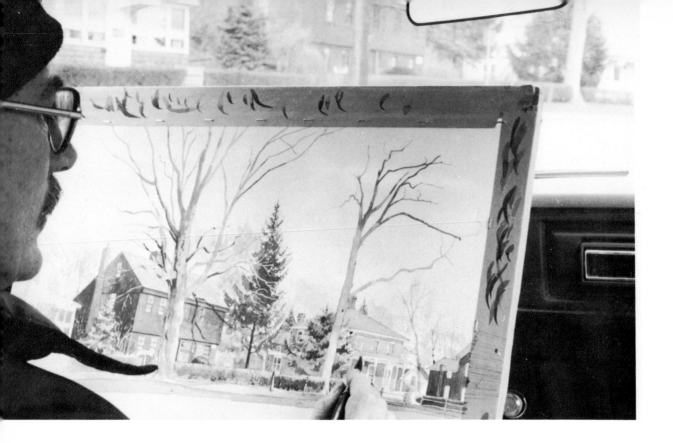

"He's not sittin' there all that time for nuthin'"

When you're in a car drawing and painting, you sometimes cause the anxiety of local residents. It's a good idea, if you're drawing a specific house, and there are people around, to let them know what you're doing.

The quotation above was an actual comment I overheard one day while I was working in my car quietly on a residential street. I later introduced myself to the gentleman who made the remark, and he turned out to be quite friendly when his mind was eased that I wasn't someone "casing" the place for possible mischief.

We're living at a time when suspicion is rampant. A stranger sitting in a car for a couple of hours may be interpreted to be a CIA agent, a mobster, or any of several unsavory characters. Sometimes police stop by in order to check me out, usually in response to a telephoned complaint by one of the residents who wasn't sure of my motives.

Occasionally I've regretted asking for permission first because some people are then inclined to talk for a long time, and I don't get my work done. If you like to get some background material on the house or building you're painting, this is a good way to do it. People like to chat with artists. And if they can show off a little of their knowledge of the history of the neighborhood or the place you're painting, they'll cheerfully do it.

This magnificent old salt box on Main Street in Branford, Connecticut is kept in almost perfect condition, although it dates back to 1753. The photograph was snapped from the same spot I sat when I painted the watercolor. The photo shows how I've left things out and made subtle changes in parts of the composition. The character of the house and surrounding trees, however, has been retained. In the photograph notice how the utility pole is directly beside the large tree. In the watercolor I saw no reason for including the pole at all. It is not an inviolate rule to eliminate utility poles—in some paintings it may be appropriate and in keeping with the character of your picture to retain such poles.

The Harrison House

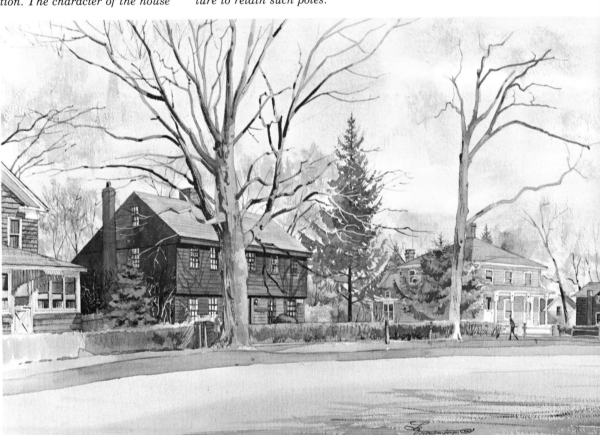

CHAPTER 5

Tiptoeing into full color
by starting with
ultramarine blue and
burnt umber

Beginners are apt to find it a bit frightening to use a full palette for the first time. This is why I have my fledglings start with just two colors and gradually work their way up to using the primaries and all the secondary colors.

To me, the ideal colors to start out with are ultramarine blue and burnt umber. One is warm, and the other is cool. You can mix them together to produce some beautiful grays or a rich black.

For practice, do a gradation similar to the one above, using these two colors. Don't expect it to be perfect the first time you try it. It'll take some practice before you feel comfortable with the mixing. When you have some command of the color and the washes, try painting a simple subject.

Carpenter's Gothic at Sunset Beach

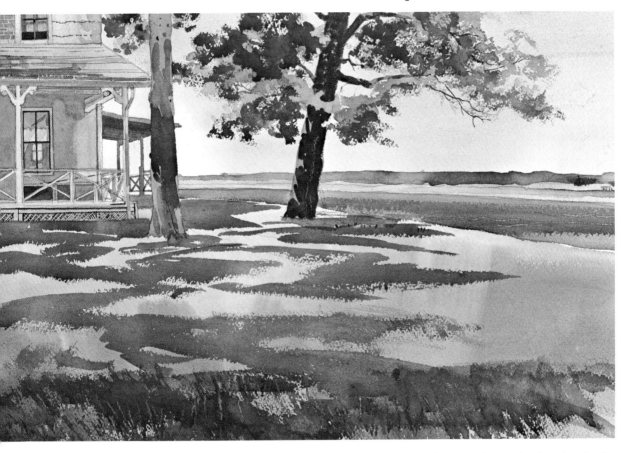

In this painting notice how local color has been almost totally ignored. The water is blue, but the grass and foliage are mixtures of the two colors that are more concerned with textures and values. The hills in the background have a little more ultramarine in them than do the washes in the foreground. Objects and forms in the background are generally cool, while the foreground tends to be warm.

Now you're ready to add two more
colors to your palette, so let's try

yellow ochre, burnt sienna,
burnt umber and ultramarine blue.

My theory in having the inexperienced artist work with these colors is that he is able to simulate the primaries without really using them yet. The yellow ochre is a less intense yellow than the cadmium or lemon yellow. Burnt sienna is more subdued and grayer than crimson or cadmium red, and yet it gives the effect of being red when it is isolated or surrounded with complementary color. And, of course, with our old friends, ultramarine blue and burnt umber, we can produce rich darks.

Practice mixing these colors. Don't mix all four, but try producing colors, mixing the yellow ochre and ultramarine blue together. Then experiment with combining the burnt sienna and ultramarine. Burnt umber and yellow ochre will also produce interesting combinations when mixed together. Vary the amount of water and notice the changes in intensity of colors you get. Try painting a simple subject with these four colors. A corner of your room or a still life subject using just three objects will do.

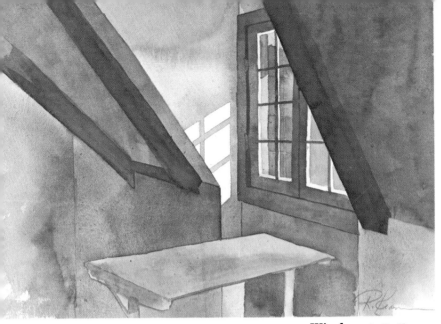

Window *by R. Kramer*

Classroom at Prospect *by Linda Lyons*

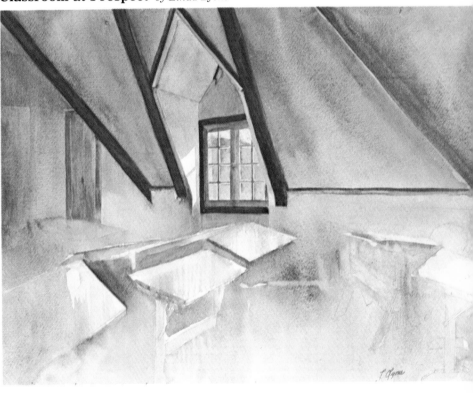

The painting on the top of this page was done by one of my first year students at Paier College. The painting has great sensitivity and does not appear to be painted using a limited palette. It really demonstrates how little color you need to produce exciting results.

Of course, this is the type of subject that isn't too difficult, even though the perspective may seem a bit complex for a beginner.

The subject directly above, involving a window painted from inside is a good method of studying value relationships. The point you should bear in mind here is to keep the window area the lightest value in your composition. Even with the lights on inside, the value of the daylight as seen through the window will always be lighter than the inside light.

Since you've had experience now with some earth colors and ultramarine, you should be ready to use

full color

To become more familiar with using the primaries, try mixing the three together in varying proportions.

Using cadmium red, cadmium yellow, and ultramarine blue, mix as many *different* grays as you can.

Your first efforts will probably result in browns rather than grays. Mind you, I didn't say to mix equal proportions of these three. Vary the amount of each color. You might mix about 10 percent red, 20 percent yellow, and 70 percent blue. Experiment with the proportions until you can control the color easily.

Try floating a cool gray wash. Put it next to a warm gray wash. To make it cool, add more blue. To make it warm, add more red and yellow. Now try to mix a completely neutral gray that will fit between the two.

Color is highly individual. So with enough practice and experimentation, you'll develop your own individual color style. Later on, as you work with more sophisticated color combinations you'll probably want to adhere to a policy of not mixing more than two colors together at a time. But for now, the mixing exercises described here will help you develop your sense of color.

Arranging your palette

If you have a palette like this one, you don't have to fill every compartment with color. Most watercolorists use between eight and twelve colors per painting. Some people start with a clean, white palette and add colors as they need them. I do not recommend such a procedure as a way to improve your painting skills. You should start with enough pigment on the palette so that during the heat of your performance, you don't have to stop and squeeze out paint.

The palette shown here is arranged similarly to my own. In general, the warm colors are on one side and the cool on the other.

It's not by accident that the ultramarine and burnt umber are placed directly opposite each other. I use these two colors a lot and it's convenient to have them where they can be easily mixed to produce grays and black.

You'll notice that no black or white pigment appears on my palette. Beginners are often tempted to use black in order to go darker with a color or to gray it. It is far better to use the complements. Many professionals use black successfully, but if you're not careful, it can creep into the other colors and muddy them. White pigment shouldn't be on the palette simply because too much of it will keep your painting from being transparent watercolor. Painting with opaques (gouache)—that is, mixing white with the colors, is a different medium with different problems.

It's better if you don't clean your palette after each use. Clean the center mixing area but leave the pigment in the compartments. Wiping the center with a wet tissue will keep this area clean for mixing your colors.

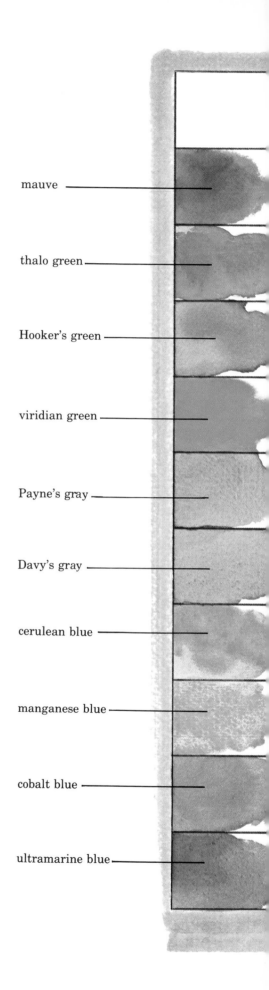

mauve

thalo green

Hooker's green

viridian green

Payne's gray

Davy's gray

cerulean blue

manganese blue

cobalt blue

ultramarine blue

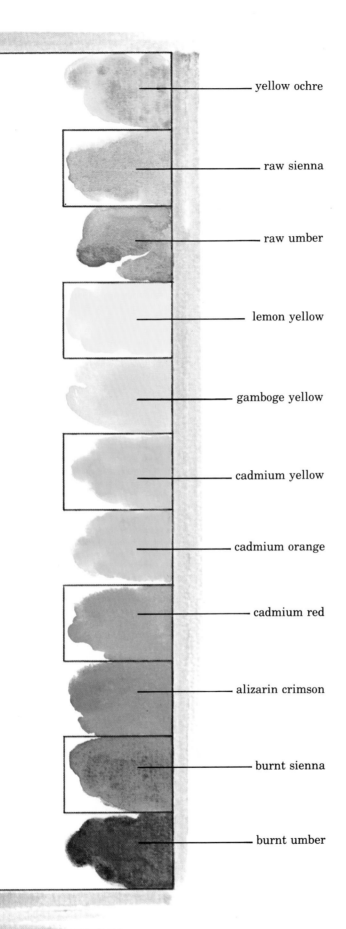

yellow ochre

raw sienna

raw umber

lemon yellow

gamboge yellow

cadmium yellow

cadmium orange

cadmium red

alizarin crimson

burnt sienna

burnt umber

Painting stones
and rocks

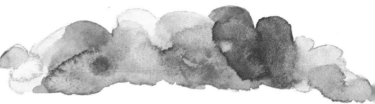

Step 1

Rocks are marvelous for practicing color painting. Step 1 shows how colors in various intensities are merged together while wet. When dry, they lighten and gray considerably. In step 2, notice how darks between the rocks given them form.

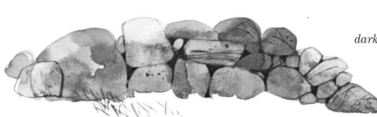

Step 2

This painting is one of the ferry landing at Frye Island, Maine. The rocky promontory is a good example of one way to do an accumulation of rocks. Notice on the right how the rocks are clearly defined, while on the left they've been simplified.

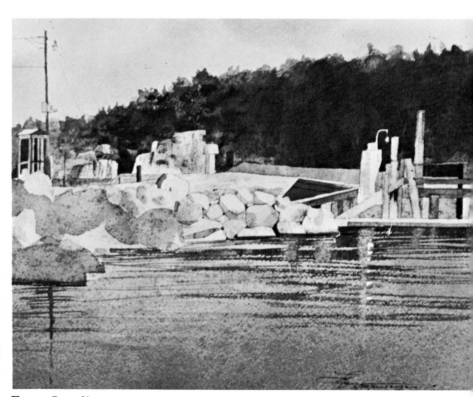

Ferry Landing *Collection: Mr. and Mrs. Aldic Johnson*

58

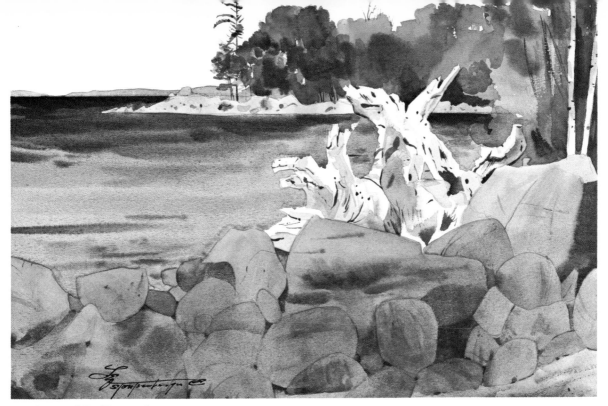

Rocks and Driftwood *Collection: Mr. and Mrs. Clifton Halter*

In the example above a different technique for painting the rocks was used. First I painted them quite objectively and detailed. When the color had dried, I felt that they appeared to be overworked and too detailed. So I mixed a glaze of color and covered the whole rocky area with this glaze. This had the effect of pulling the color together, allowing the driftwood to become prominent.

When snow is on and around large rock formations, the effect can be most appealing. Here the curvature of the rock shapes contrasts with the rigid lines of the trees.

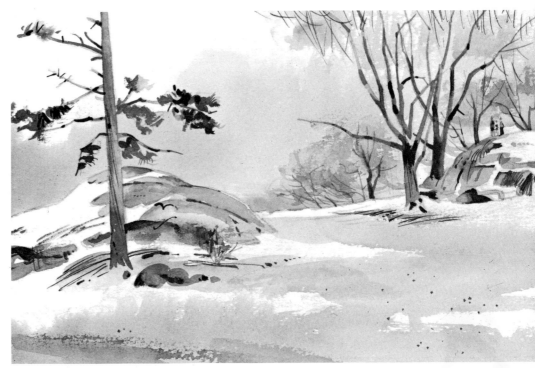

Winter. Branford Point *Collection: William Velmure, Jr.*

To suggest atmosphere in landscape painting,
it helps to consider the background in
terms of

Zones

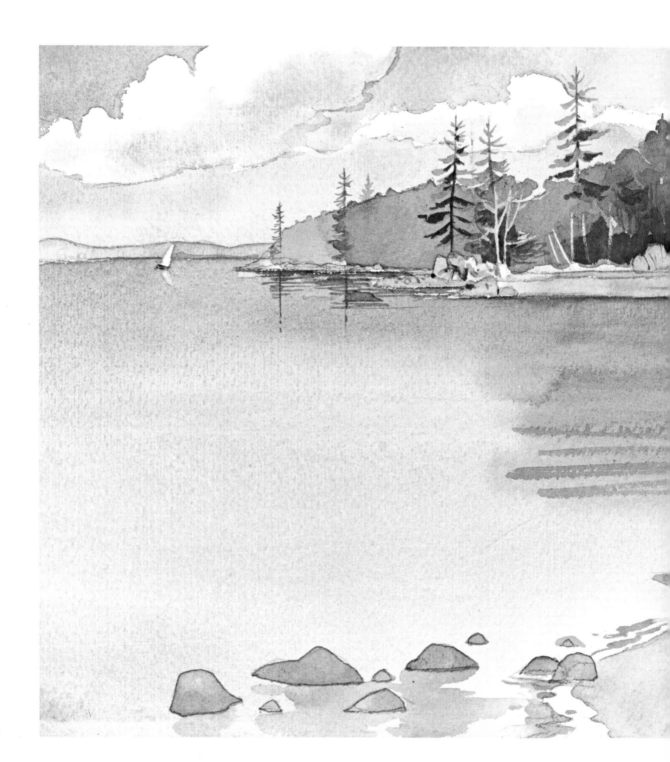

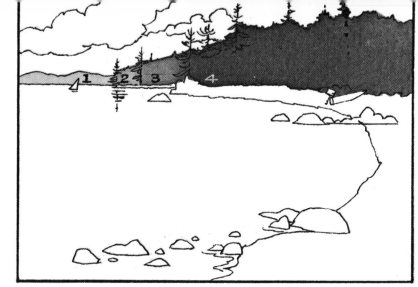

The diagram at the right should be clear. No. 1 is the lightest value because it's farthest away. No. 2 is a bit darker because it is closer. No. 3 is darker still because it's nearer the viewer.

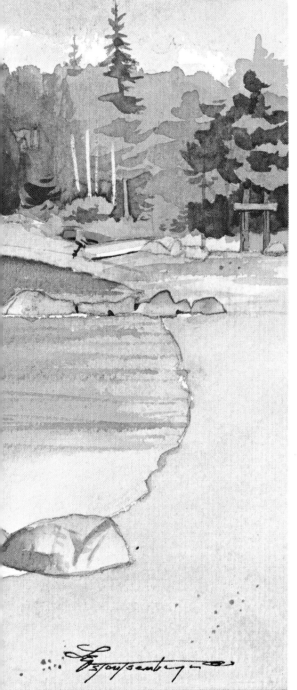

I sat on a camp stool to paint this scene at Frye Island. There's something about the blue sky, the sandy beaches, and clear, clean lake water that makes almost anyone want to come back to Maine again and again. This is the kind of picture that keeps me going when enduring the cold winter months, huddled by a fire to stay warm.

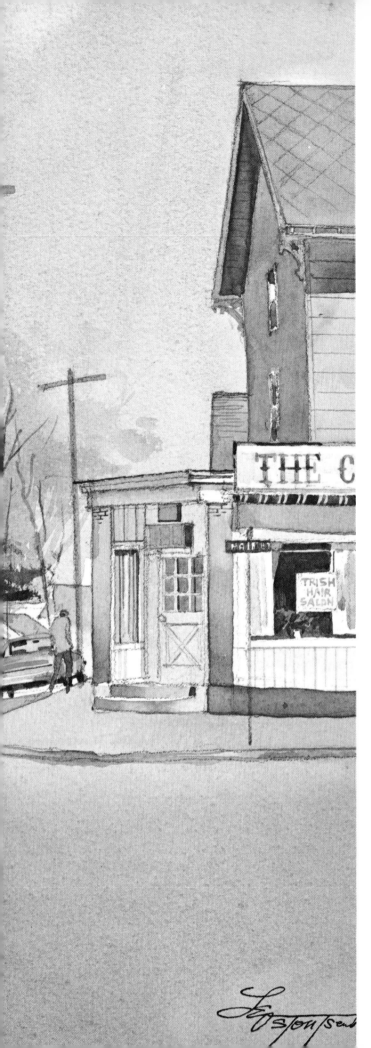

The small town street corner

There are interesting, paintable corners in almost all towns and cities. It sometimes takes a little ingenuity to be able to park in a spot that gives you a clear view of the subject.

There is a minimum amount of perspective to be concerned with in this view in Branford. The interesting variety of grays and the variations of textures make the subject a pleasure.

The Corner Shop

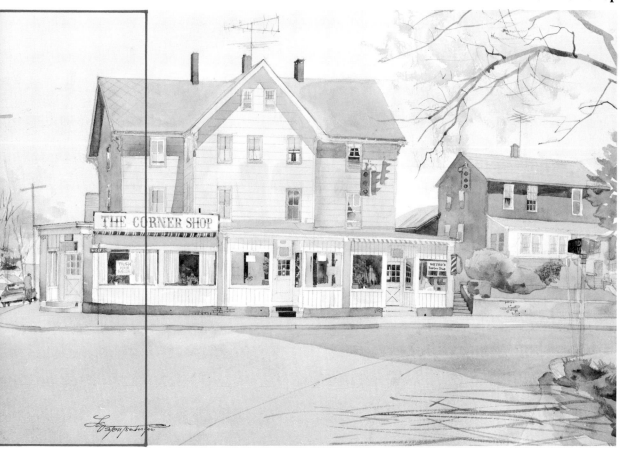

The section of the picture with the red line around it, shown on the left, is reproduced the size of the original painting. The grays in the same size reproduction are similar to the grays used in the exercises shown earlier.

For the garden center, shown below, a felt tip pen was used, with splashes of color added for decorative quality.

Flower Shop on Montowese

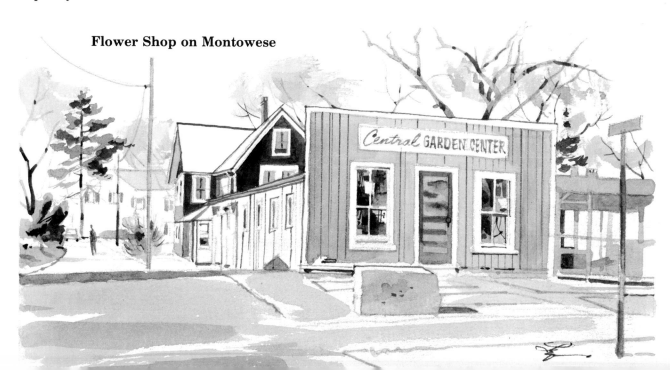

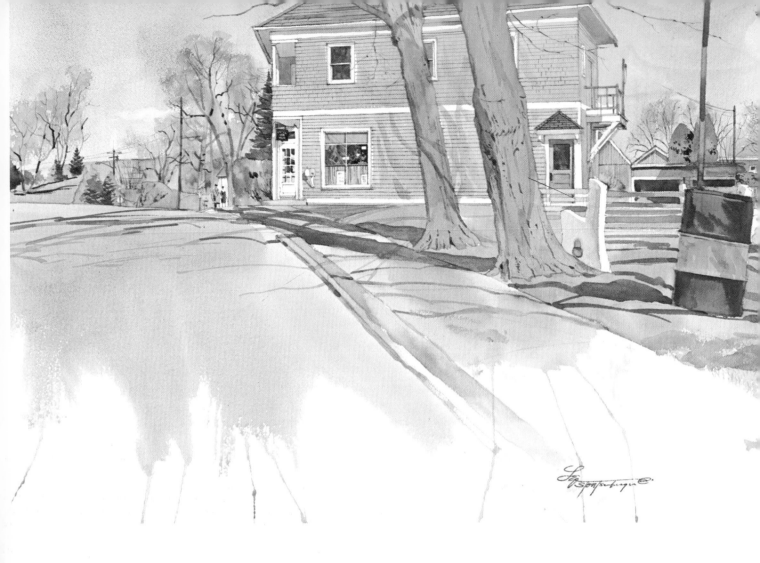

Stony Creek is a part of Branford with easy access to Long Island Sound. Boats, interesting little shops, and old Victorian houses are plentiful. The Thrift Shop is a place I've painted several times. It's a peaceful corner, except at certain times when this little establishment which sells used items becomes as busy as a supermarket on the day before Thanksgiving.

When you hold your painting board at a fairly steep angle as it rests on the steering wheel, you're likely to get trickles of color that run uncontrolled down the surface of the paper. When they began to develop on this painting I decided to leave them. In fact, after one or two had started, I encouraged the others to happen. This was done by moving in close and blowing the color in the direction I wanted it to follow. Charles Reid uses this technique with considerable success.

Two streets coming together usually provoke an interesting reaction. Here converging lines of the curbs give the picture an obvious focal center. The two buildings facing us are nineteenth century houses and are typical in their basic simplicity.

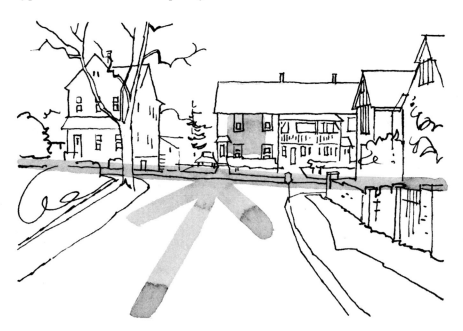

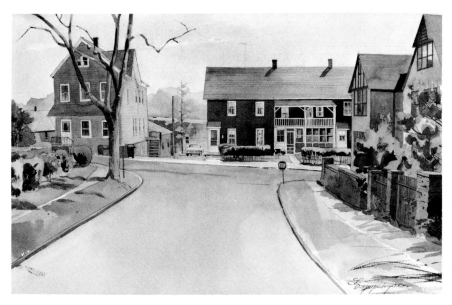

The painting was done in early Spring before the foliage had begun to develop. I like the way the sun touches the yellow house, but the house directly ahead of us is seen in shadow. Notice how the textures on the right wall have been simplified.

CHAPTER 7

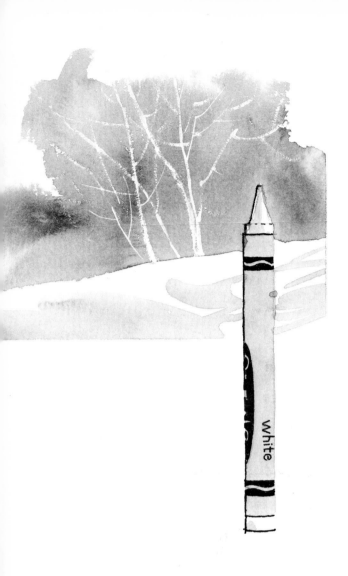

Tricks

Many people think watercolor is a medium full of tricks. To a degree this is true. Tricks and lucky accidents can create a kind of sparkling magic, but these delightful effects occur only when the artist has paved the way for them. Practice all the trick effects you can, but remember you cannot sustain a meaningful painting career on tricks alone.

The reproduction at the left is based on the obvious principle, grease and water do not mix. A white wax crayon is used to draw on the surface of the paper. After this, washes of color are applied directly over the wax. The water is repelled by the wax, leaving an irregular white line. Such lines often have a unique character not possible to duplicate in any other way.

Another useful bit of gear capable of producing interesting effects is a match folder. I like the character of line achievable when you draw with the edge of the matchbook.

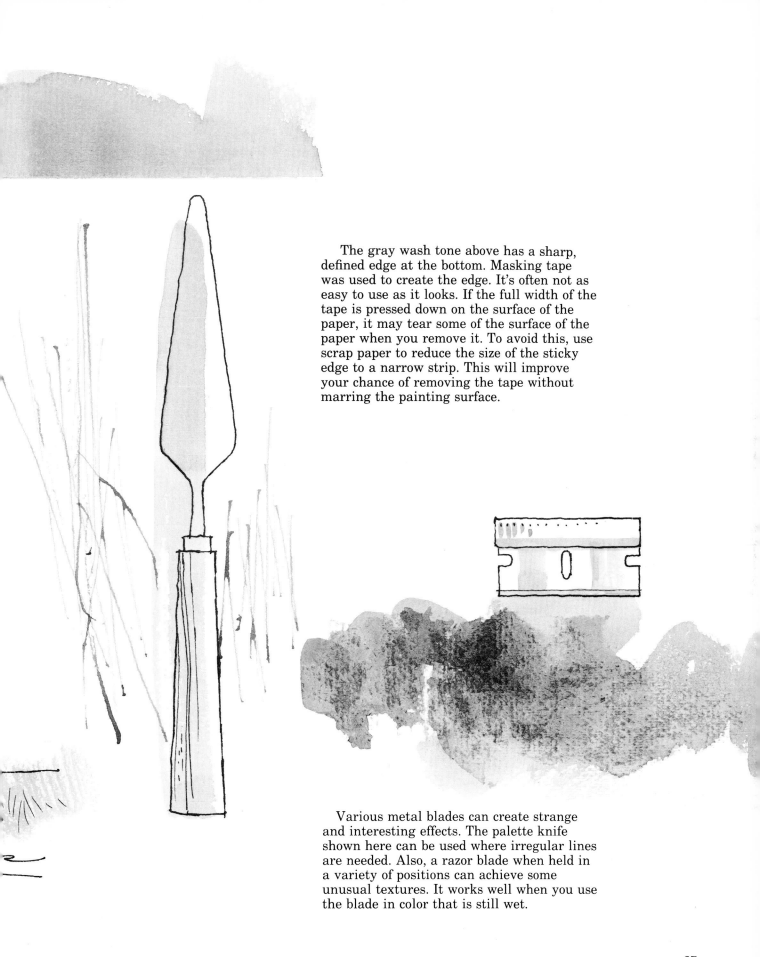

The gray wash tone above has a sharp, defined edge at the bottom. Masking tape was used to create the edge. It's often not as easy to use as it looks. If the full width of the tape is pressed down on the surface of the paper, it may tear some of the surface of the paper when you remove it. To avoid this, use scrap paper to reduce the size of the sticky edge to a narrow strip. This will improve your chance of removing the tape without marring the painting surface.

Various metal blades can create strange and interesting effects. The palette knife shown here can be used where irregular lines are needed. Also, a razor blade when held in a variety of positions can achieve some unusual textures. It works well when you use the blade in color that is still wet.

Tips

Painting controlled pictures sometimes requires checking measurements. Many people rely on rulers, but I don't like them as they are cumbersome. **Instead of a ruler, try using small scraps of paper.** If you want to repeat a size or shape and it must be accurate, mark the size down and use this as an engineering draftsman might use a pair of dividers.

Practice with a larger brush than you feel comfortable using. Learning to control large brushes is a key factor in improving your skill in handling the medium. Some effects can only be achieved with a large brush. You'll be amazed how much a little practice will help.

Keep your pencils sharp! Whether you use an electric pencil sharpener, or one of the new battery jobs, or a small portable sharpener or the old, single edged razor blade, keep sharp points on your pencils. It is difficult to achieve any degree of sensitivity using a blunt or worn pencil. Your pleasure in drawing will be increased immeasurably if you work with a recently sharpened pencil.

White poster paint. If you have need to use this, do so sparingly. In certain small spots of your painting, you can get away with it if you're careful. You shouldn't put it onto your regular palette, however. When the white paint gets into the pigment, you are no longer using transparent watercolor. In most instances you'll want to preserve the quality of the watercolor by emphasizing its transparency throughout the painting.

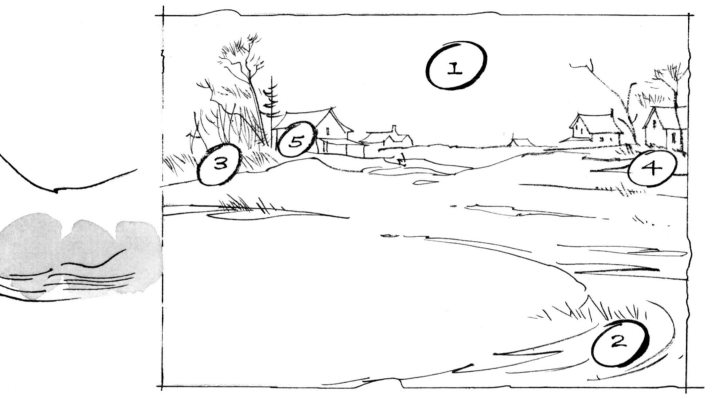

Wherever possible, work from the largest shapes to smaller ones. The diagram above, showing a pencilled-in drawing, is preparatory for a watercolor, I've placed numbers to indicate the order in which to apply your washes of color. Notice that there is some space between washes 1 and 2. Also the other washes have sufficient area around them to allow the wash to dry before applying the next wash. This is done to avoid having the washes run together where you don't want it to happen.

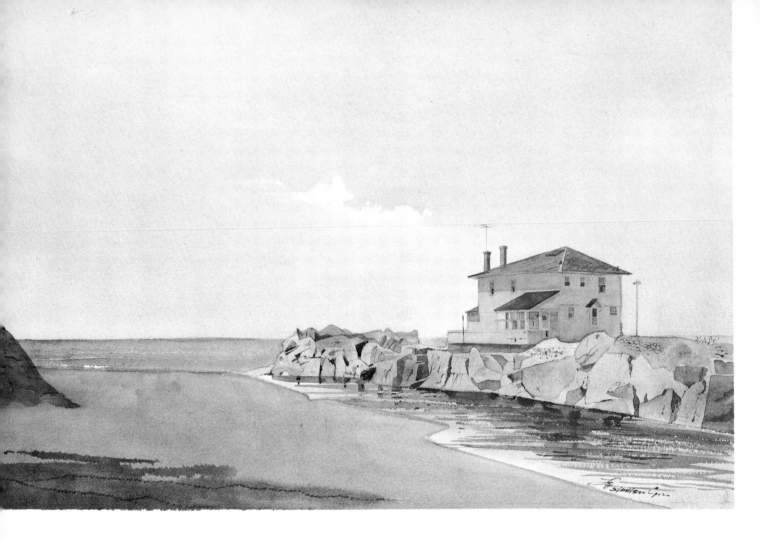

Pullouts

Pullout technique for cloud effects

The technique of pulling color out while it's still wet can be a useful addition to your painting skills. To use this procedure successfully requires some practice. Don't just dab at the color after you've painted it. You should know exactly what effect you're after before you start.

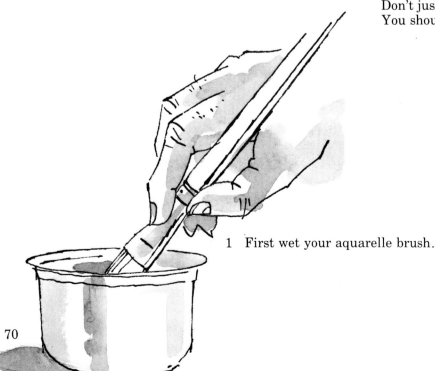

1 First wet your aquarelle brush.

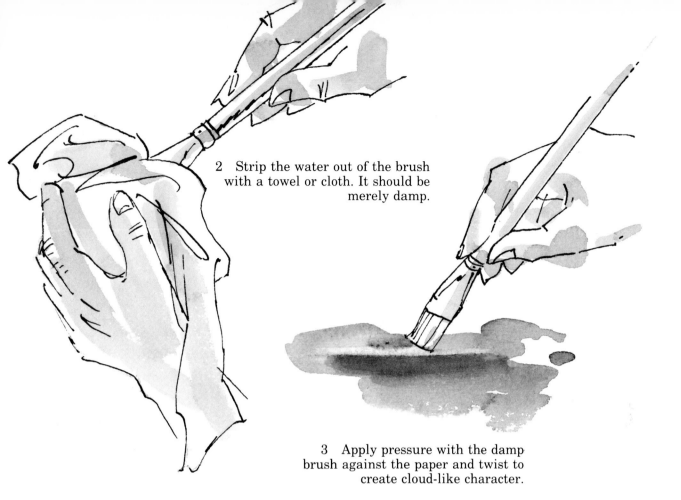

2 Strip the water out of the brush with a towel or cloth. It should be merely damp.

3 Apply pressure with the damp brush against the paper and twist to create cloud-like character.

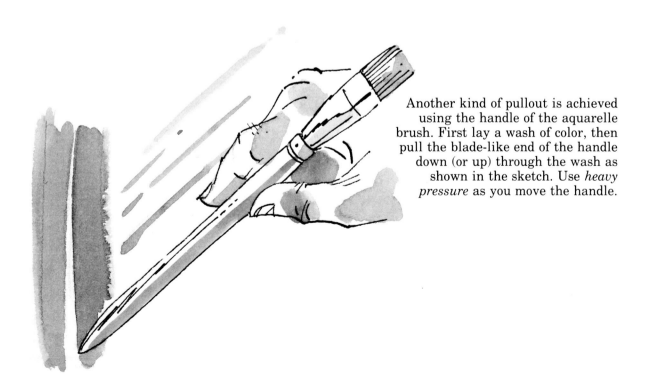

Another kind of pullout is achieved using the handle of the aquarelle brush. First lay a wash of color, then pull the blade-like end of the handle down (or up) through the wash as shown in the sketch. Use *heavy pressure* as you move the handle.

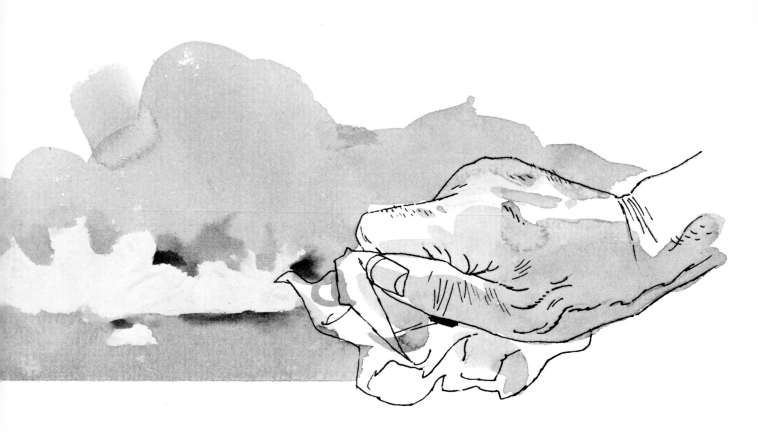

Tissues may be used also as pullout devices. Soft cloud effects can sometimes be created by dabbing tissue on the still damp wash. Make sure the color you put down is dark enough so there'll be sufficient contrast between the value of the cloud and the sky. When you try this, press the tissue hard against the surface of the moist paper. You'll find that you can come up with some dramatic and exciting clouds this way.

Bristle brushes designed to be used for oils or acrylics are good for taking out small areas of color after the color is dry. Just wet the area and scrub with the brush until the unwanted paint can be lifted off with tissue, blotter or sponge.

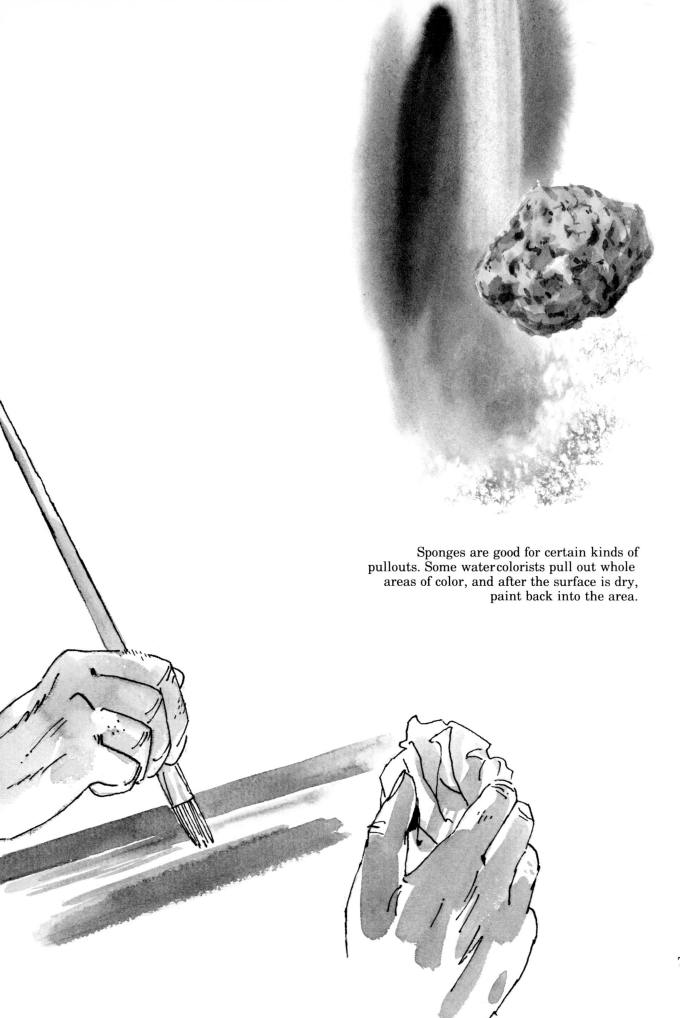

Sponges are good for certain kinds of
pullouts. Some watercolorists pull out whole
areas of color, and after the surface is dry,
paint back into the area.

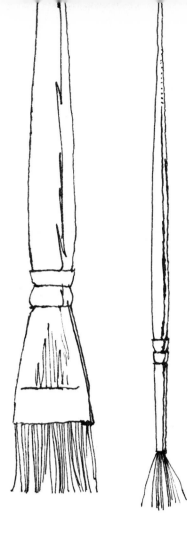

Try textures with your old, worn brushes

When it comes to throwing away old brushes I become a mite sentimental. Some of my brushes go back to the Stone Age—almost! It's a mistake to try to produce a wash or a controlled area with an old brush. But , for those interesting areas that seem to need a somewhat different approach, try an old, worn brush and see what happens!

Scumbling and bearing down and twirling the brush to suggest all kinds of textures can be great fun.

Before trying these effects on your watercolor, pull out some old paper and practice some squiggles, dabs, and swirls similar to those shown here. Try moving your fingers, wrist and elbow.

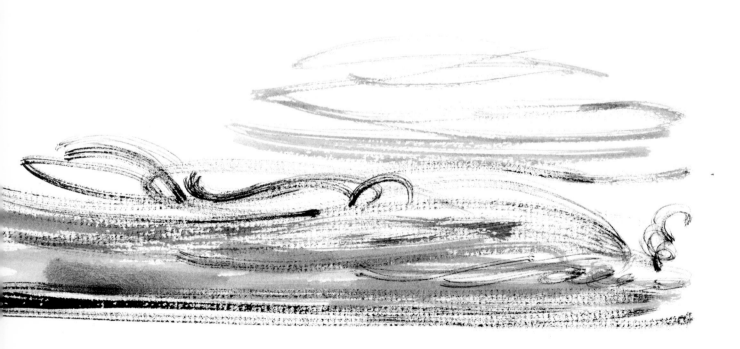

74

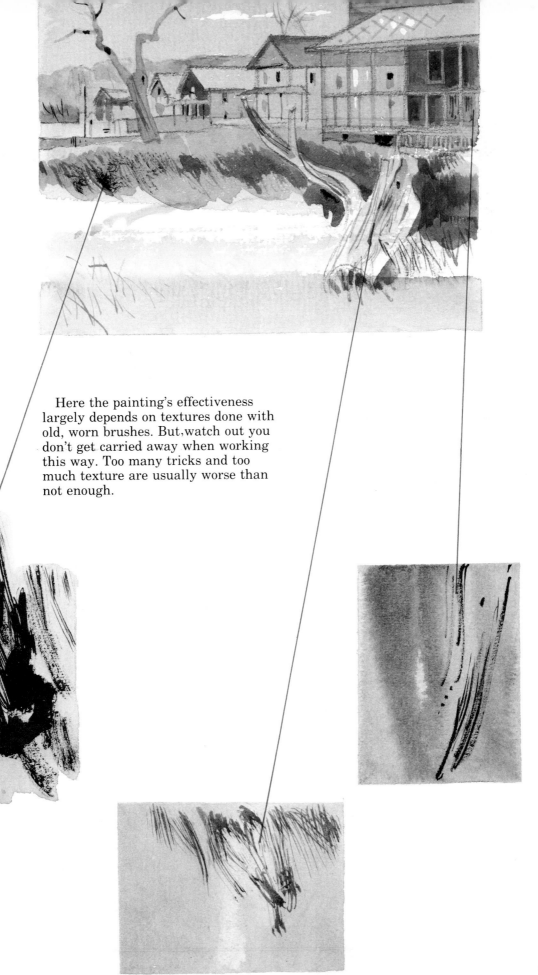

Here the painting's effectiveness largely depends on textures done with old, worn brushes. But watch out you don't get carried away when working this way. Too many tricks and too much texture are usually worse than not enough.

House in Noank

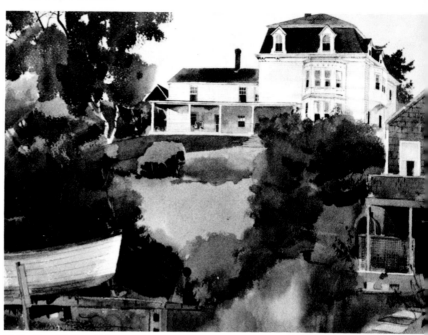

Collection: Lillian Erb

Drawing straight lines with a brush

Some painters maintain there is no reason for painting straight lines. However, I often find it useful to be able to paint reasonably straight lines when their use seems appropriate.

The technique I use is nothing new. I learned the procedure from a sign painter many years ago. The method works better than running the brush directly against the straight edge.

When painting architectural subjects like the one above, this method of drawing straight lines is used on the parts of the houses where uniform lines are necessary.

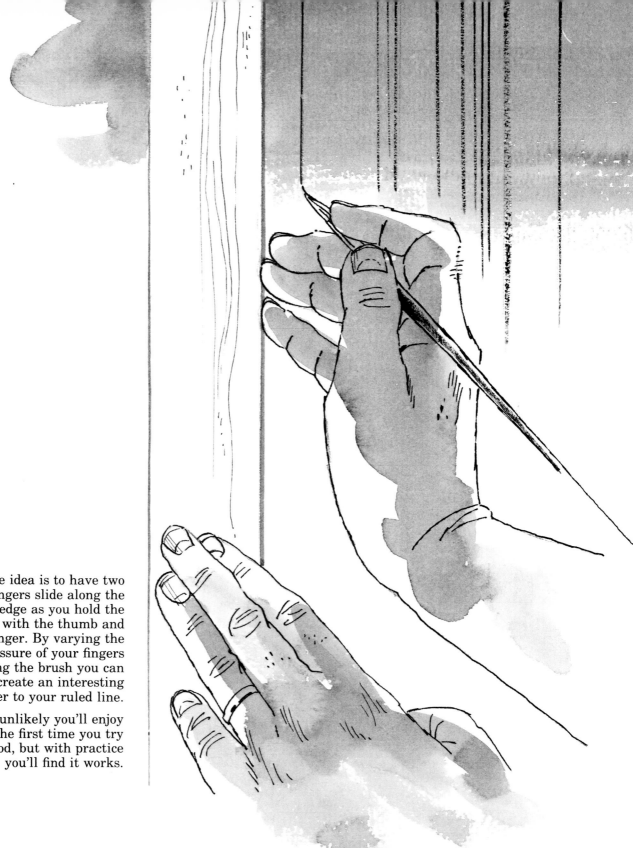

The idea is to have two fingers slide along the straight edge as you hold the brush with the thumb and index finger. By varying the pressure of your fingers holding the brush you can create an interesting character to your ruled line.

It is unlikely you'll enjoy success the first time you try this method, but with practice you'll find it works.

Using felt tips
with watercolor

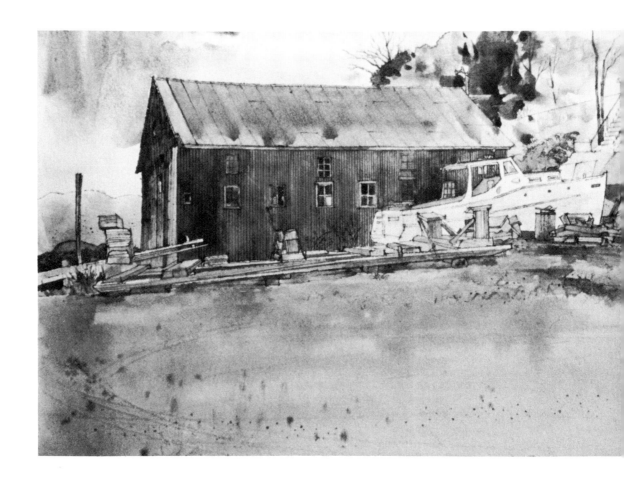

A large percentage of my pictures are painted in pure watercolor with no additional materials used. However, sometimes I like to vary the process. The permanency of some materials such as felt tipped pens is questionable, but there is no doubt about the creative pleasure you can derive from using them.

The line, as it runs and skips along the uneven surface, creates strange and wondrous images. When you add water, which affects the ink in an unpredictable way, you'll understand some of the joys of experimenting with felt tips.

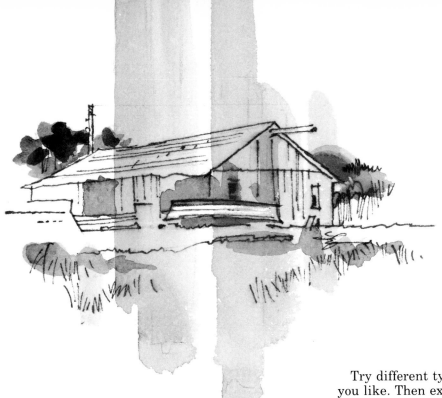

Try different types—until you find the one you like. Then experiment. The manufacturers of these pens are constantly changing them so you're never quite sure the pen you like will be available six months from now.

Felt tips have a habit of running out of ink or going dry when you're in the middle of a drawing. For this reason it's advisable to have several and keep well supplied. Fortunately, they are fairly inexpensive. I find a pen will last me about two months if I'm sure to keep the cap on when not in use.

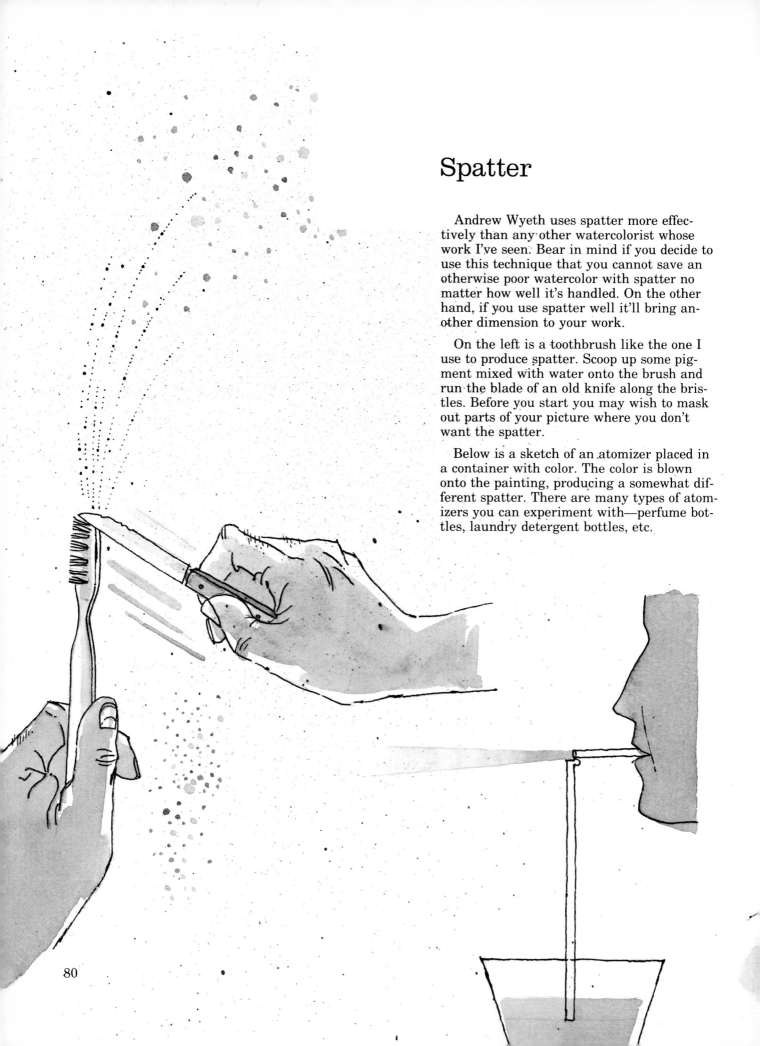

Spatter

Andrew Wyeth uses spatter more effectively than any other watercolorist whose work I've seen. Bear in mind if you decide to use this technique that you cannot save an otherwise poor watercolor with spatter no matter how well it's handled. On the other hand, if you use spatter well it'll bring another dimension to your work.

On the left is a toothbrush like the one I use to produce spatter. Scoop up some pigment mixed with water onto the brush and run the blade of an old knife along the bristles. Before you start you may wish to mask out parts of your picture where you don't want the spatter.

Below is a sketch of an atomizer placed in a container with color. The color is blown onto the painting, producing a somewhat different spatter. There are many types of atomizers you can experiment with—perfume bottles, laundry detergent bottles, etc.

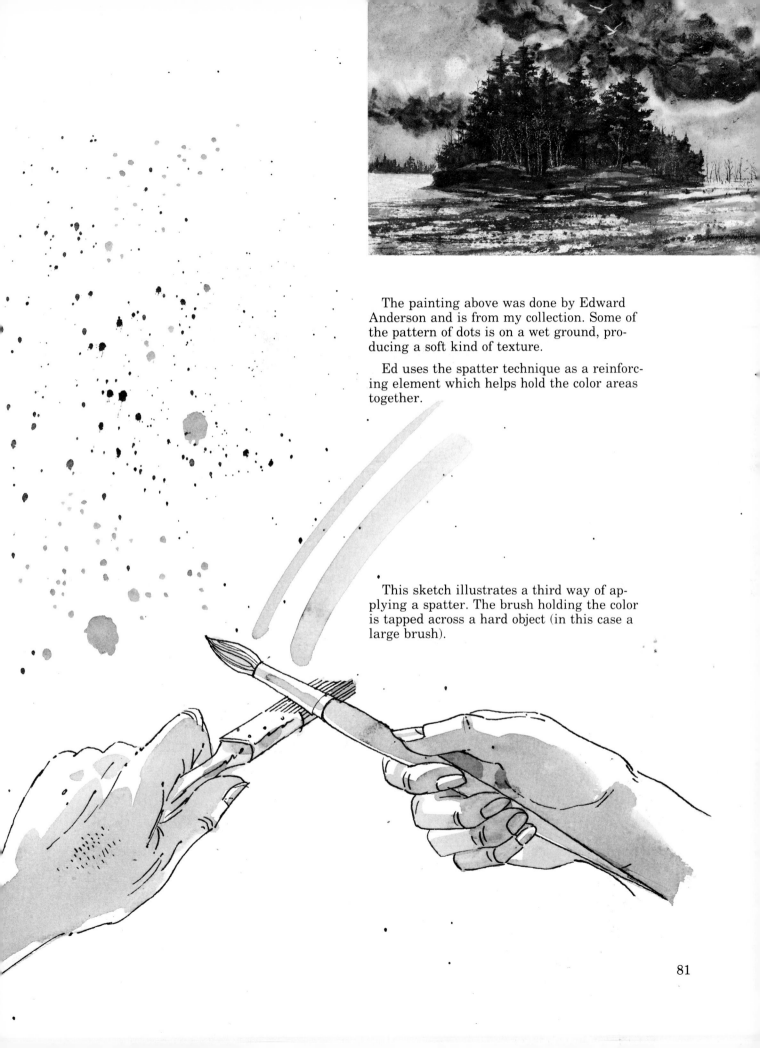

The painting above was done by Edward Anderson and is from my collection. Some of the pattern of dots is on a wet ground, producing a soft kind of texture.

Ed uses the spatter technique as a reinforcing element which helps hold the color areas together.

This sketch illustrates a third way of applying a spatter. The brush holding the color is tapped across a hard object (in this case a large brush).

For unusual and interesting textures
Let your fingers do some of the work

Finger painting as a complete procedure leaves much to be desired. However, I often get my fingers into the act because it is the only way some textures can be produced.

Smudging with the tips of your fingers while the color is still wet and fresh on the paper can give you just the right effect. I've never found another way to do it.

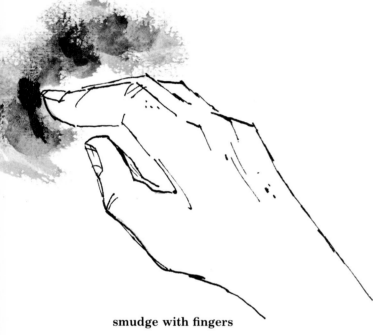

smudge with fingers

In this painting finger smudging was applied in the area of the tops of the trees. Thumbnail and fingernails were used in the foreground grassy areas.

Sunset Beach
Collection: Mr. & Mrs. Ralph Weber

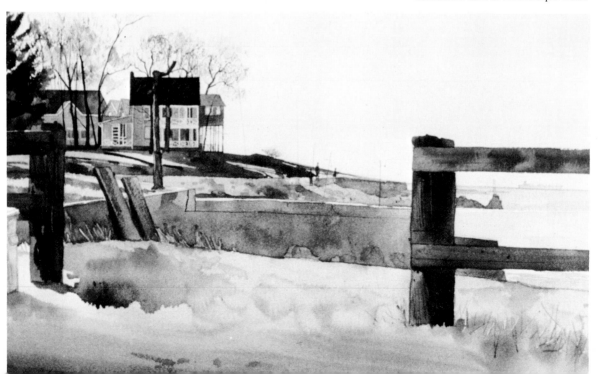

82

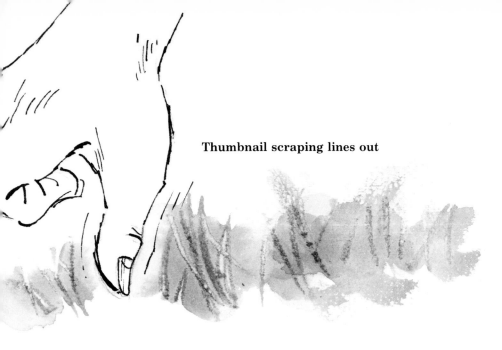

Thumbnail scraping lines out

Usually I use the brush handle of the aquarelle brush to achieve the negative linear effects. However, there are times when I want a thinner negative line only achievable by using my thumbnail. Painting in this manner will give fingernail biters an incentive to stop.

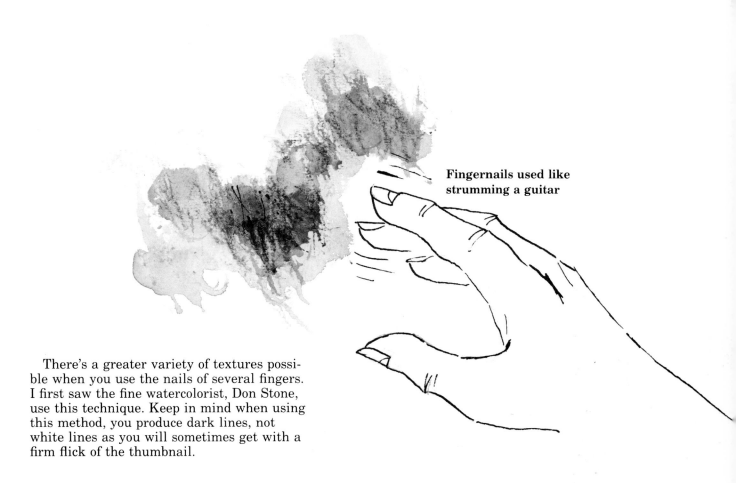

Fingernails used like strumming a guitar

There's a greater variety of textures possible when you use the nails of several fingers. I first saw the fine watercolorist, Don Stone, use this technique. Keep in mind when using this method, you produce dark lines, not white lines as you will sometimes get with a firm flick of the thumbnail.

For negative effects and
exciting variations in value
you'll want to try

Liquid frisket

1 Drawing made in pencil

2 Frisket painted over pencil drawing

3 Background colors painted directly over frisket

There are times while painting in watercolor when you must show light lines against dark values. Several products available in art supply stores make this possible. Miskit, Moon Mask, and Maskoid are three such products. This material is somewhat like rubber cement. Of the three products, I've found Moon Mask works the best.

It's advisable to use a fairly good sable brush because in order to properly control the fluid you must be able to manage a point on the brush. The frisket washes out of the brush in water and will not harm it.

One advantage the Miskit brand has is that it is colored a bright orange. This makes it easier to see, allowing you to remove all the material from your painting more efficiently.

The long white streaks in the snow were done using Maskoid. For me, this product is a bit harder to control than the other products mentioned.

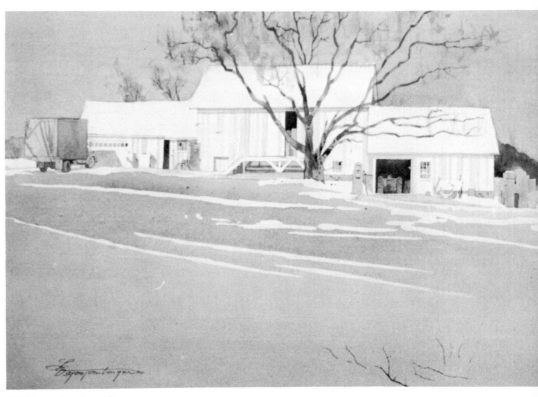

Hilltop Orchards

Collection, Mr. & Mrs. Joseph Funaro

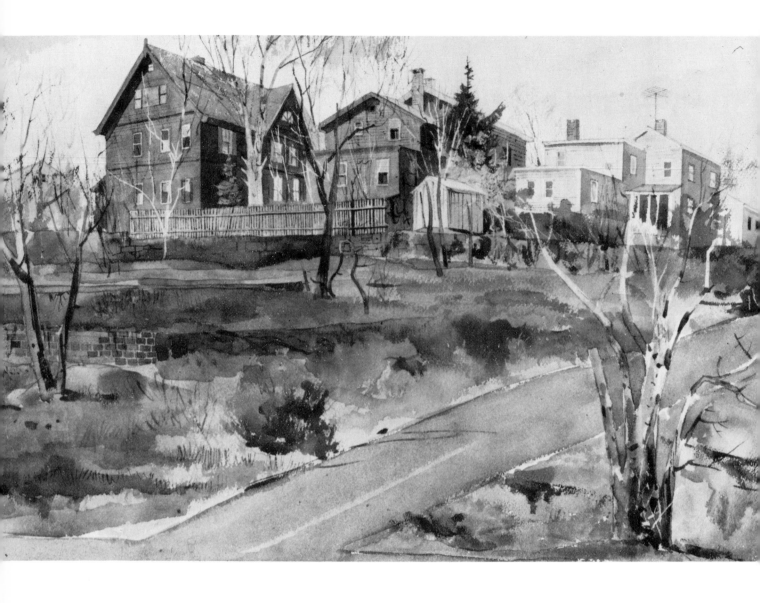

In the painting above I used Moon Mask exclusively. It's used in a number of areas. Notice particularly the places where the mask was not used on white paper, but was painted on top of color so as to show gray tones in the midst of very dark passages.

Masking fluid should be used with care and planning. It won't work well if you just dab and dash here and there in a random manner.

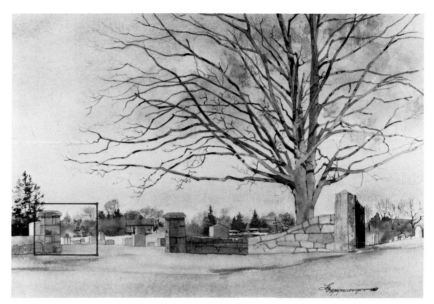

Tabor Cemetery

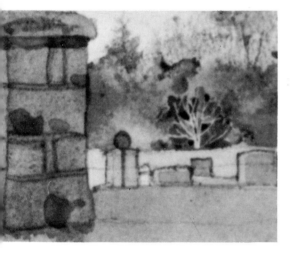

This picture is reproduced the same size as the original painting. It is a portion of the picture above shown inside the red line. The tree has been entirely drawn with the Miskit, but the area was first treated with a light gray wash. The wash was allowed to dry and then the Miskit was applied in the shape of the small tree. After it was dry, darker colors were painted over it. Later the Miskit was removed, leaving the lighter color of the tree.

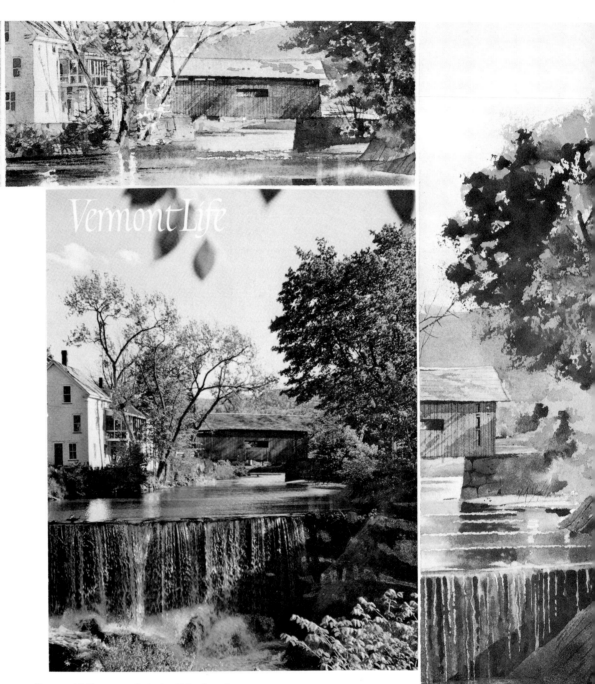

Vermont Life cover photo by John Lynch

for practice on
your watercolor techniques,
copying

Photo clippings
can help

In the demonstration layout on the left, a
photograph taken from a magazine cover was
used as a model. The purpose in copying
these sections is to concentrate on producing
textures and values and color. This can be a
learning experience.

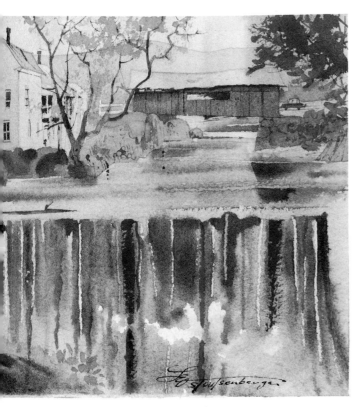

*The painting above shows a departure
from the original photo. Certain liberties
have been taken with the subject. When
you use photographs, you don't have to be
limited by them.*

Stretching the paper

The term "stretching" always seems a bit misleading. Actually, the paper expands when it's wet, and as it dries it resumes its previous size.

I've been stretching paper for my watercolors for over twenty years. It seems like a lot of work and bother. It isn't, and it's well worth the effort. To me, few things are worse than painting on a surface that buckles, bubbles or bends. The beauty of the stretching method is that, although there might be slight buckling after laying down a wet wash, as it dries the paper comes back to a perfectly flat state.

It's important that you use the proper tape for this procedure. *Don't use masking tape!* Masking tape will not stick where there is water. The type of tape you must use can be bought in most stationery stores or hardware suppliers. It's usually called gummed mailing tape.

1 Soak paper by immersing in a couple of inches of water. A bathtub or shower stall work well for this operation.

4 The sheet of paper is placed on a drawing board.

2 The paper is dropped into the water and allowed to stay for several minutes.

3 Next I remove the paper and place it against the shower wall. Remove excess water from paper with your hand.

9 Now you're finished. It's best to wait overnight to check on how it's worked. In the morning all the buckles will be flattened out and you should have the perfect watercolor surface upon which to work.

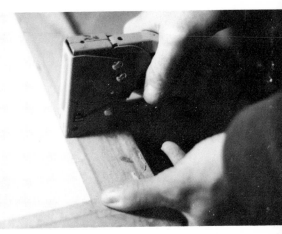

8 Use a heavy duty stapler to reinforce the paper. Place these staples about three inches apart all around the four sides. The tape shouldn't cover more than three-eighths of an inch of paper all around.

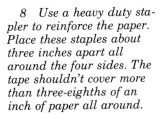

7 As you attach the tape, rub it vigorously, using a lot of pressure. Place strips of tape around all four sides.

5 The first strip of tape that has been pre-cut, is pulled over a wet sponge. Make sure the tape is thoroughly moistened.

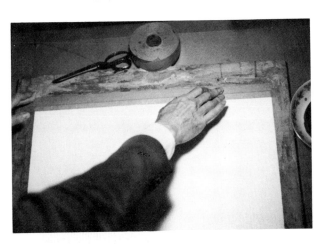

6 Now place the tape against the paper.

91

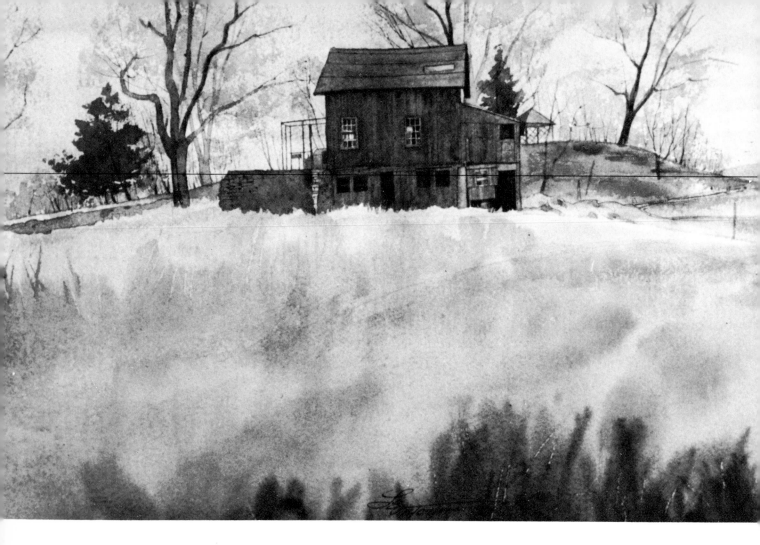

CHAPTER 8

"Where shall
I place the eye
level?"

This should be your first concern when you
begin a painting on location. You're sitting in
one spot, so it really becomes a matter of
raising or lowering the view finder (which is
by now etched in your brain). In the painting
above, you lower the VF, thus bringing the
eye level up high. Obviously, you eliminate
much of the sky this way, and the foreground
becomes a large element to deal with.

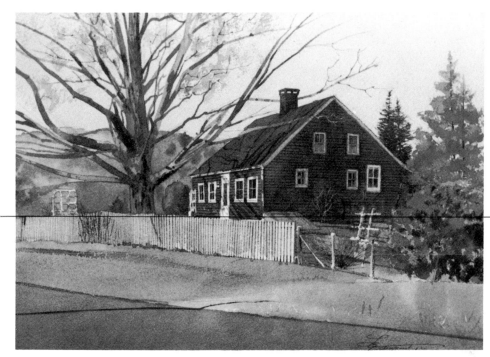

In the painting above, I decided to have the eye level below the center because I wanted to include as much of the tree as possible. The subject is a fine old eighteenth century shingle-covered house in North Guilford, Connecticut.

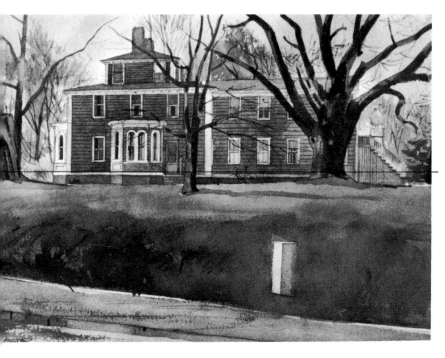

Compositionally, it is usually best to avoid splitting a picture in the middle either horizontally or vertically. However, in this instance I decided to risk it. Remember, after you've been painting for a while you're permitted to break the rules if there is a good enough reason. The reason for avoiding splitting a picture in half is to create more interest and variety in the major shapes. Sometimes this condition can be overcome by the way you use the color, line and values.

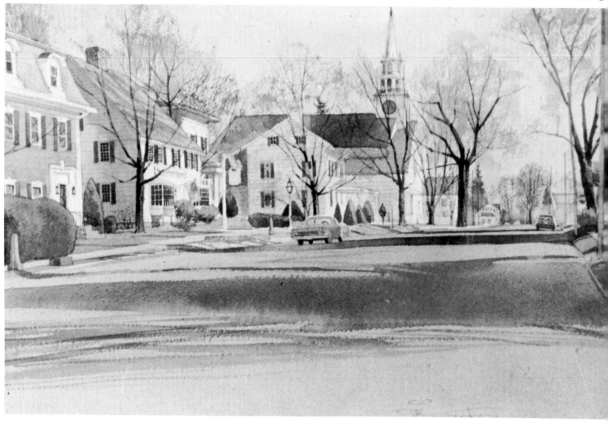

Perspective

Accurate perspective drawing often strikes terror into the hearts of beginners. The only way to overcome this is by drawing as many man-made forms as possible and apply the simple rules of perspective frequently. You'll soon learn to put the demon to rest.

In painting the subject reproduced above it was difficult to find a time to work when the street was not crowded with cars. Because of this I found myself returning to the scene on Sunday mornings before the traffic began to build up. This enabled me to see and draw those parts that were at other times obscured by the vehicles. I've included two cars only to help with the scale. As a rule, I prefer to leave cars out of most of my paintings unless they contribute to the interest of composition.

The diagrammatic sketch below illustrates how one-point perspective works. When painting this kind of subject I wouldn't dare carry out the drawing entirely by eye, although some artists can work without worrying about accuracy. It is always more satisfying to me if the perspective checks out correctly. What appears reasonably accurate to one person may look terribly distorted to another. Unless distortion serves a purpose in your picture it is best to keep the man-made elements within the bounds of plausibility.

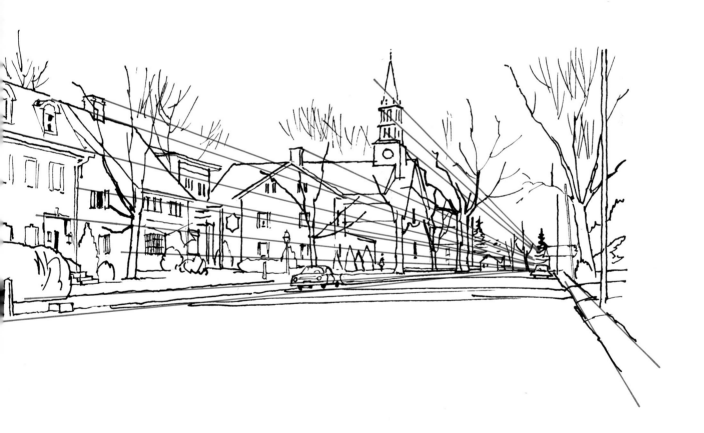

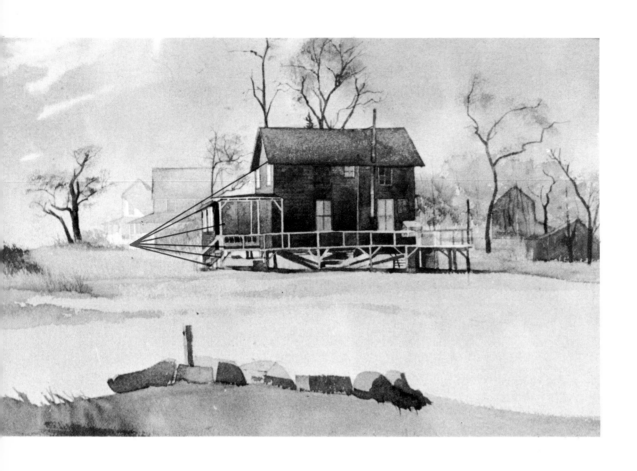

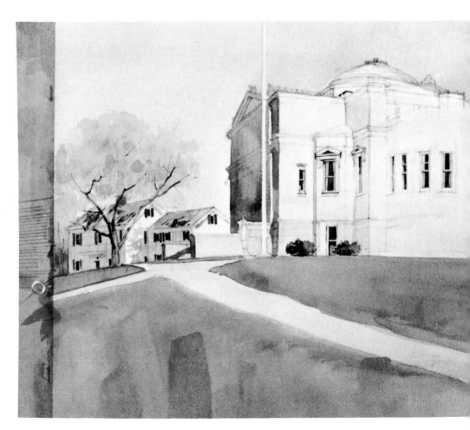

96

What makes such a subject worthy of the effort to make the perspective accurate? To me, it is a unique cluster of buildings along a street; such a scene excites me. Perhaps this is the kind of thing you like, or something else turns you on. Whatever the subject, you'll find you enjoy it more and will paint it better if you like it.

The painting at the top of the opposite page is another example of one-point perspective, but this time used only sparingly. Notice that the clouds in the upper left corner of the picture also seem to reflect the use of perspective.

Often when using two-point perspective the vanishing points appear off the paper. This is the way I solve the problem. The lines going to a vanishing point on the left are drawn on the brown paper tape that goes around the edge of the paper. Notice how the lines drawn on the right side of the painting go to the vanishing point on the right.

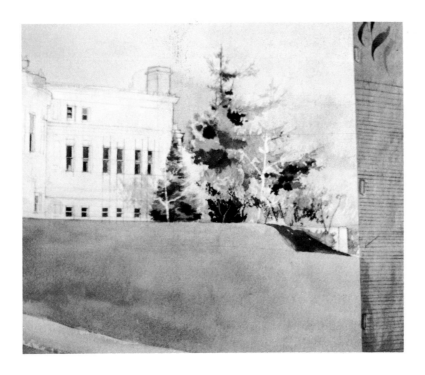

My method of working up the perspective lines for my paintings is probably rather unorthodox. But any system is valid if it gets the job done. Certainly my procedure has the virtue of simplicity.

Between our house and the studio is a concrete, enclosed terrace. Spread out on the floor is a rug with parallel stripes or lines woven into the fabric. I line up the drawing board along one of these lines and place another drawing board of the same thickness alongside it, but the necessary distance away to be able to locate the vanishing point.

A push pin is used to designate the vanishing point. In the photo you can see how this is done. I use a six-foot strip of aluminum as a straightedge. This enables me to connect with the vanishing point even though it might be a distance away. The push pin placed in the board makes it easy to lay the straightedge down and press it against the push pin for accuracy. Then I draw the lines along the edge of the board on the tape as shown earlier. When back at the painting site it becomes a simple matter to use a shorter straightedge to connect the lines of the drawing to the appropriate lines on the tape that surrounds the watercolor paper.

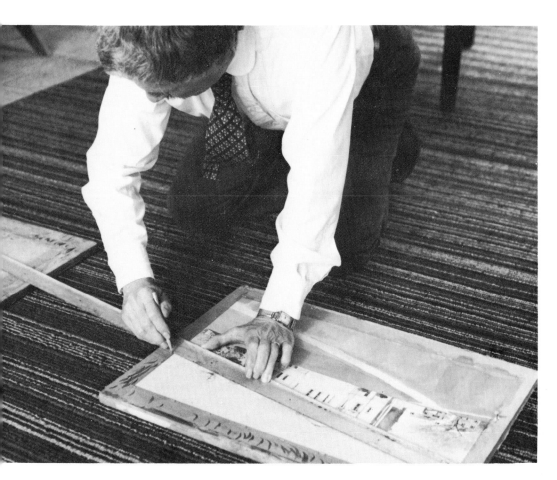

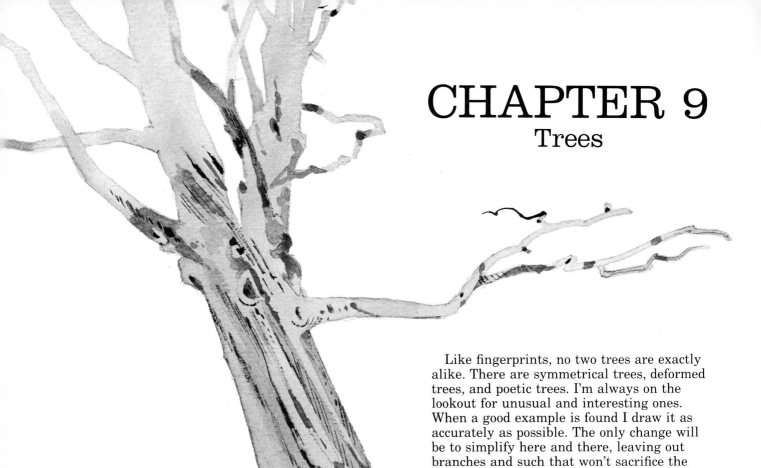

CHAPTER 9
Trees

Like fingerprints, no two trees are exactly alike. There are symmetrical trees, deformed trees, and poetic trees. I'm always on the lookout for unusual and interesting ones. When a good example is found I draw it as accurately as possible. The only change will be to simplify here and there, leaving out branches and such that won't sacrifice the character of the tree.

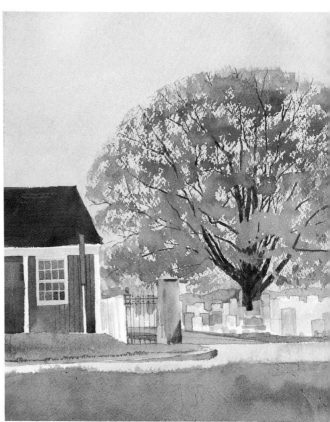

I remember from my Air Force days, olive trees in Castelluccia, Italy. The twisted, contorted branches and trunks give these trees a unique quality and character all their own. There is also a wide variety of interesting trees in this area. Indeed, no matter where you live you'll be sure to see fascinating examples. Even most arid areas offer fine specimens of cottonwood, pinyon pine and others.

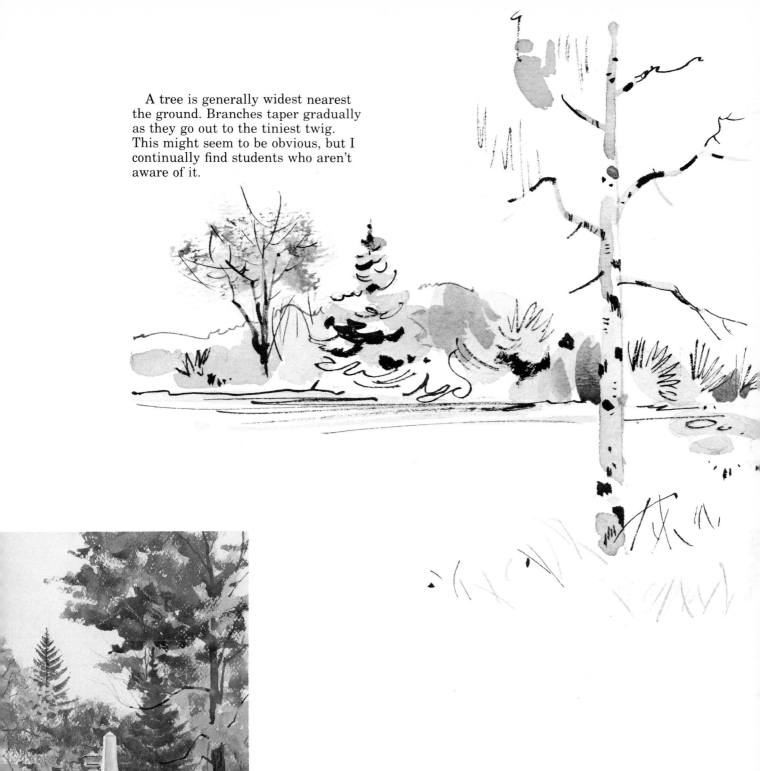

A tree is generally widest nearest the ground. Branches taper gradually as they go out to the tiniest twig. This might seem to be obvious, but I continually find students who aren't aware of it.

Branford Cemetery

Cemeteries are often good places to paint because the trees are generally given space to properly develop. In this watercolor I was intrigued by the variety of trees, and also the interplay of textures; wrought iron, weathered marble, foliage, wood and grass.

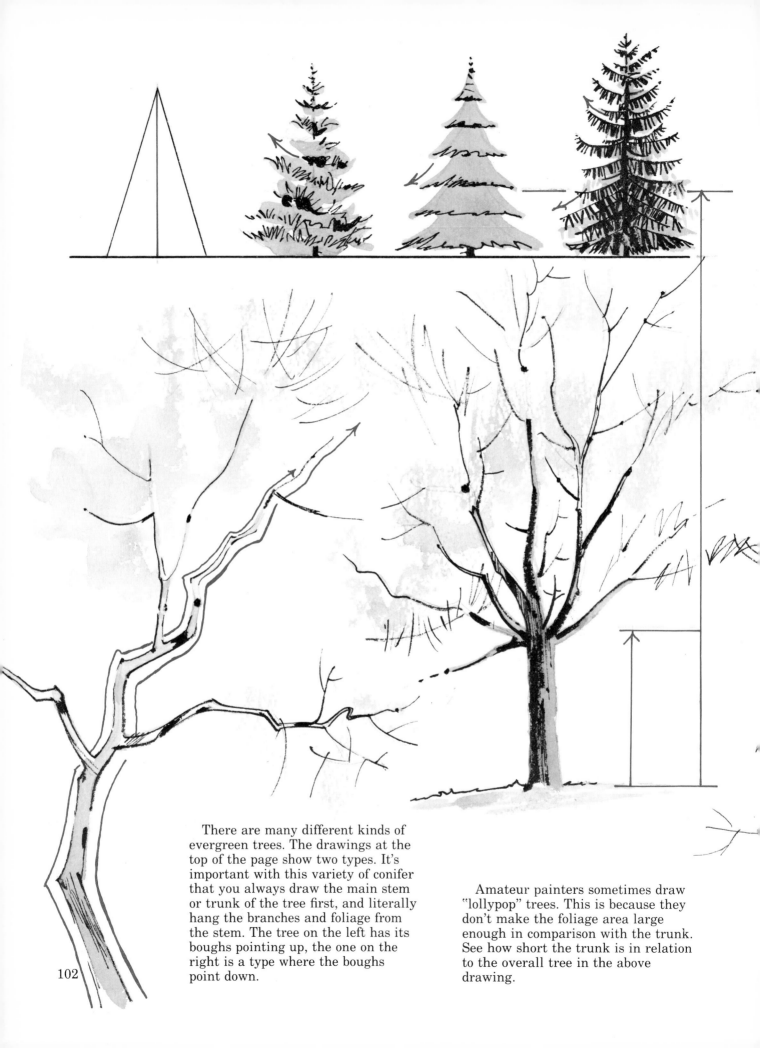

There are many different kinds of evergreen trees. The drawings at the top of the page show two types. It's important with this variety of conifer that you always draw the main stem or trunk of the tree first, and literally hang the branches and foliage from the stem. The tree on the left has its boughs pointing up, the one on the right is a type where the boughs point down.

Amateur painters sometimes draw "lollypop" trees. This is because they don't make the foliage area large enough in comparison with the trunk. See how short the trunk is in relation to the overall tree in the above drawing.

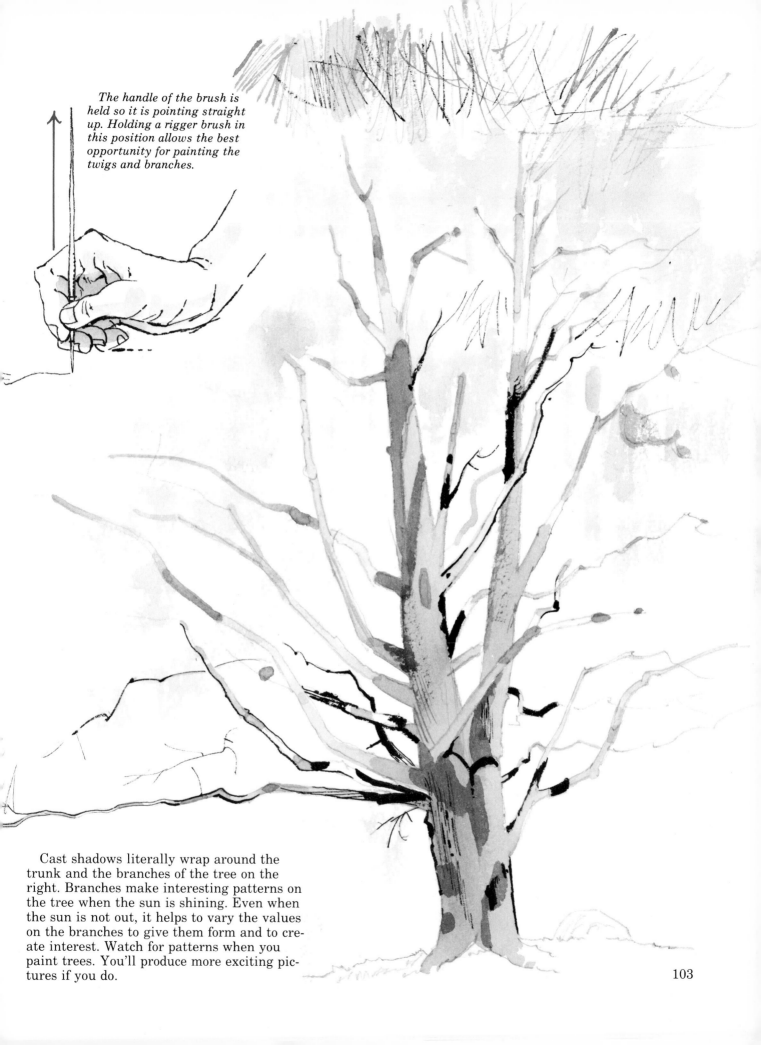

The handle of the brush is held so it is pointing straight up. Holding a rigger brush in this position allows the best opportunity for painting the twigs and branches.

Cast shadows literally wrap around the trunk and the branches of the tree on the right. Branches make interesting patterns on the tree when the sun is shining. Even when the sun is not out, it helps to vary the values on the branches to give them form and to create interest. Watch for patterns when you paint trees. You'll produce more exciting pictures if you do.

103

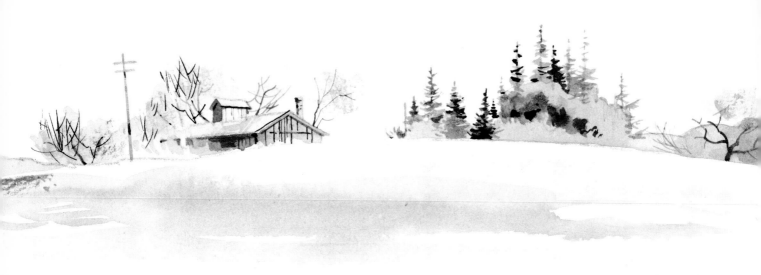

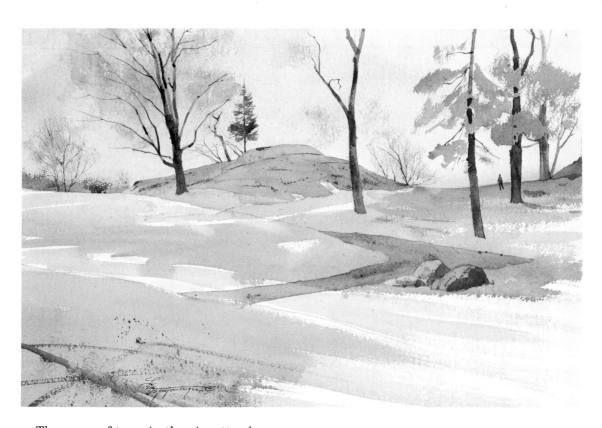

The grove of trees in the vignette above
was fun to paint. Pines have always had a
particular appeal for me, and I never tire of
painting them. The park-like picture was
painted at Branford Point. Notice how the
rock formations complement the various tree
forms.

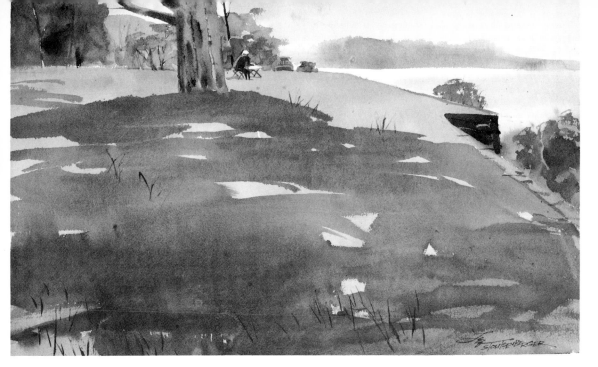

I'm rather proud of this painting made during one of Ed Whitney's class sessions which I attended some years ago. It was done in less than an hour and shows how much can be accomplished in a short time. You can tell from these paintings of trees how much I dislike painting trees in the summertime. That is why I chose not to feature the foliage, but emphasized the shadows instead.

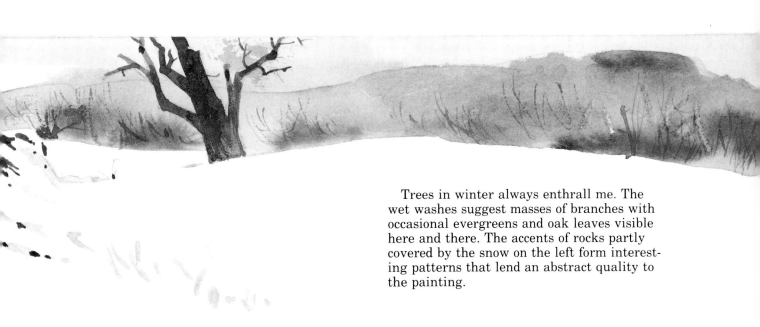

Trees in winter always enthrall me. The wet washes suggest masses of branches with occasional evergreens and oak leaves visible here and there. The accents of rocks partly covered by the snow on the left form interesting patterns that lend an abstract quality to the painting.

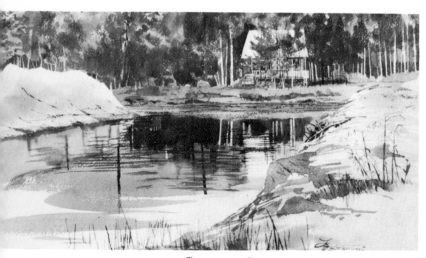

CHAPTER 10

How do you paint water?

There is no way to answer this question. It is posed here because over many years of teaching it's the one question I've been asked more times than any other. I can't tell a student how to paint water. The best I can do is demonstrate various kinds of water and how I paint them.

First of all, I point out I am not a surf painter. If you want to paint surf, study the paintings of Winslow Homer and some of Ed Whitney's work, and then go out and sit on a rock and watch the waves break the way Homer did at Prout's Neck, Maine a hundred years ago.

Summer Cottage, Frye Island, Maine

Water (unless it's cascading down a rocky ledge, or agitated by the wind) is flat—and when seen from a distance it is flat. So, when you paint a calm lake or river, make it look flat. In the painting, Summer Cottage at Frye Island, notice how the horizontals and verticals have been emphasized.

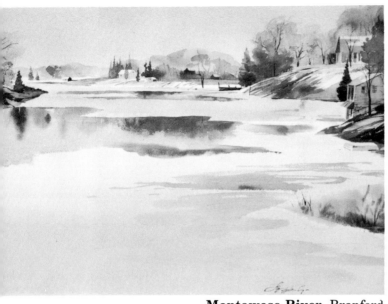

In this winter subject the wetness of the water is felt even though much of the water is covered by melting snow and ice. The horizon is kept quite high in order to have room to play with the interesting reflections and changes that take place in the water.

Montowese River, Branford
Collection: David Jansen

This is a summer view of Clam Island. It demonstrates how simply you can treat water and still make it look wet and appealing. Notice how the horizontal lines of the water become slightly diagonal as they near the bottom to conform to the natural laws of perspective.

107

Clam Island

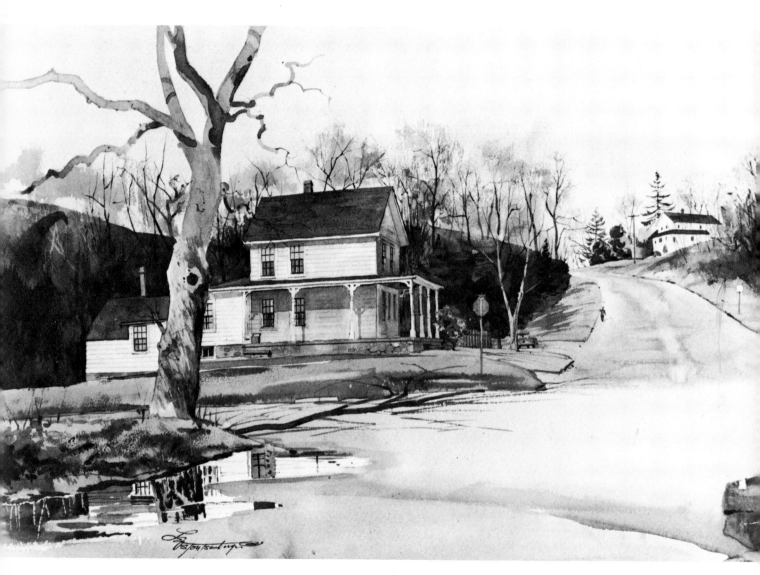

Puddles can be fascinating to paint. In this one the water's reflections become quite light in value as they reflect parts of the sky and the white house. If puddles intrigue you, you should study the works of Ted Kautzky. There are several excellent books available by this fine draughtsman and watercolorist.

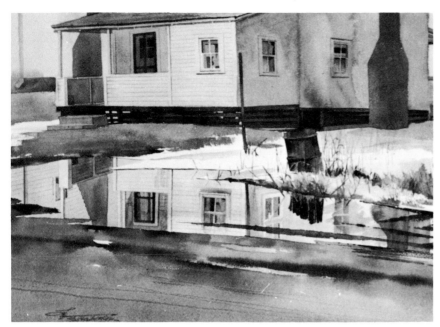

After the snow melts there are lots of pud-
dles. This one reflects part of a summer cot-
tage abandoned for the winter months at
Summer Island in Branford, Connecticut.

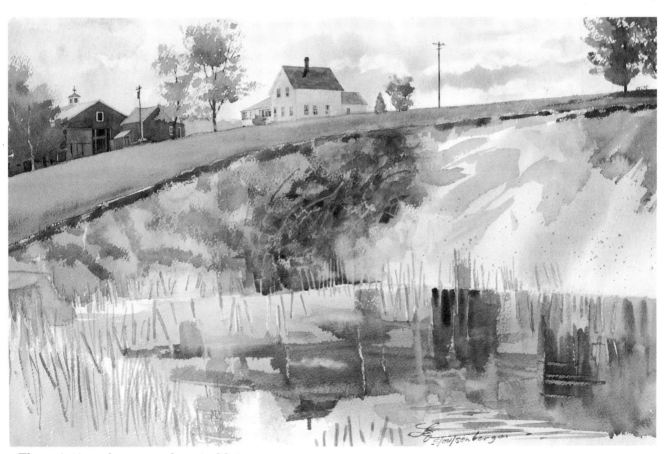

The painting above was done in Maine.
The water here is a stagnant, murky pool.
Lots of flotsam made this a desirable subject.
Notice how simply the embankment is
painted.

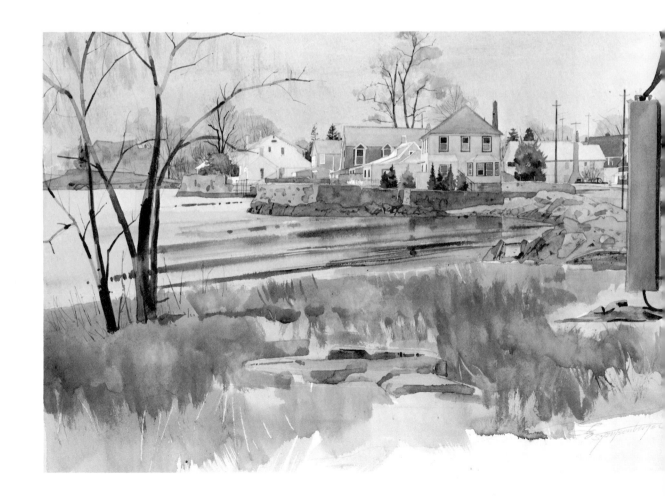

110

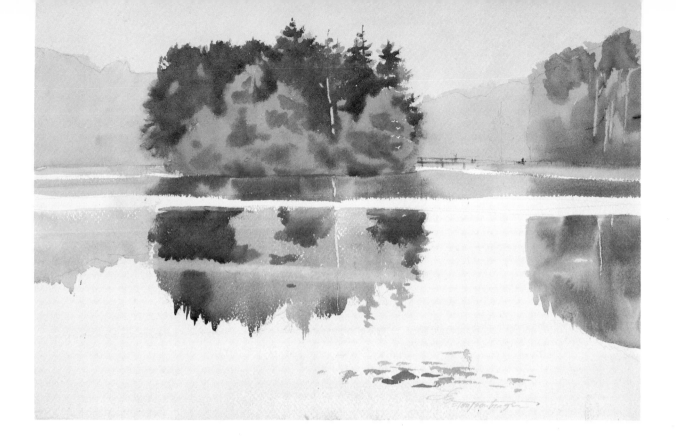

At the top of the opposite page is a subject showing water handled quite simply. Even though the water occupies a major portion of the composition, I saw no need to represent it with more than a graded wash.

In the painting on the left, a certain amount of movement is apparent in the water. The constantly changing nature of water makes it difficult to paint. However, with practice and patient observation of water, such problems will become easier.

Above is a painting of a body of water known as the Supply Pond. Actually, it's more like a small lake, but is an excellent spot to study the water and the effects of light and space in all seasons.

CHAPTER 11

Barns

When someone has done as much with barns as Eric Sloane, there is a tendency to feel there's no different or better way to approach the subject. Usually, I don't become all dewy-eyed over barns, but I guess the reason I've painted so many over the years is that they are there. And they are interesting to sketch and paint because they offer so much variety in form, texture and color.

The patina of age that comes to the surface of the weathered wood represents a challenge that makes me want to embrace it. Barns are like monuments and reminders of a slower time when life was not necessarily better, but different.

Some barns are like old friends—I've gone back to paint them many times. There is no doubt I get a lot of mileage out of the barns around us. Each time one of "my barns" burns down or falls prey to the bulldozer I cry a little. Even though you might paint the same subject over and over again, it doesn't mean that any two of the watercolors should be alike.

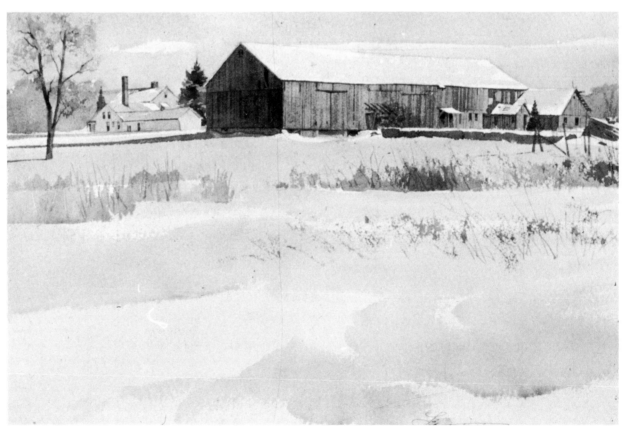

Branford Barn

Collection, Dr. Donald DiGiulian

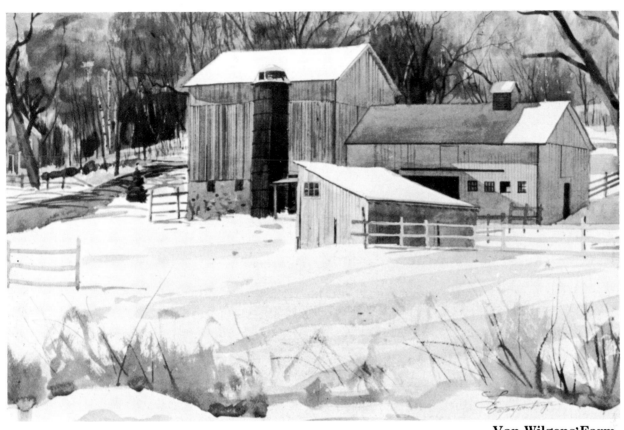

Van Wilgens' Farm
Collection, Bart and Barbara Caso

113

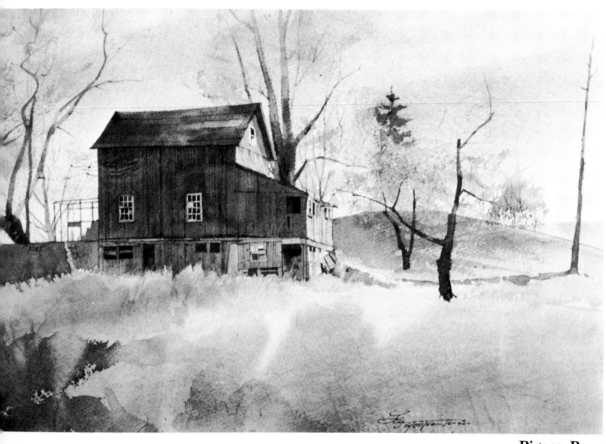

Pigeon Barn
Collection, John Haweelt

The barns on these pages are paintings of the same barn. In "Pigeon Barn" the composition relies upon the angular character of the trees that contrast with the old worn surfaces on the barn and stone wall. This is one of those subjects where it is necessary to leave out a lot.

When property is left alone for ten or twenty years, decay and deterioration take over. The artist's job then becomes more difficult because the problem of selectivity is greater.

114

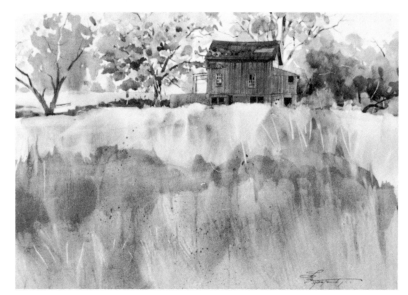

Pigeon Barn in Autumn

The painting above was done using a smooth paper. This is Arches hot press, and was painted just as the leaves were beginning to turn in early Autumn. You're forced to work more quickly on a smooth surface. This characteristic is quite noticeable, especially in the large foreground area.

Dealing with the snow creates a whole new set of challenges with the subject. There is also a lonely quality here not present in the other two compositions. This is partly because of the absence of any strong sunlight. Notice that the snow on the sloping roof is slightly lighter in value than other parts of the picture.

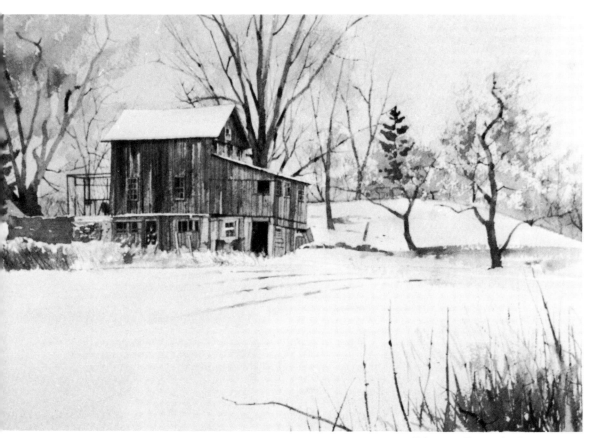

Pigeon Barn in December

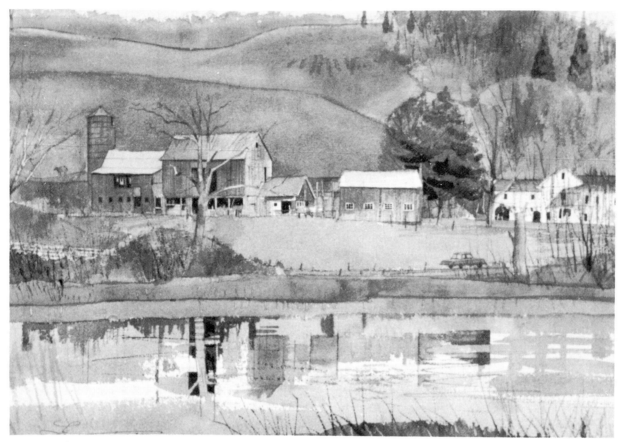

Chittenden's Farm

Halloween Barn

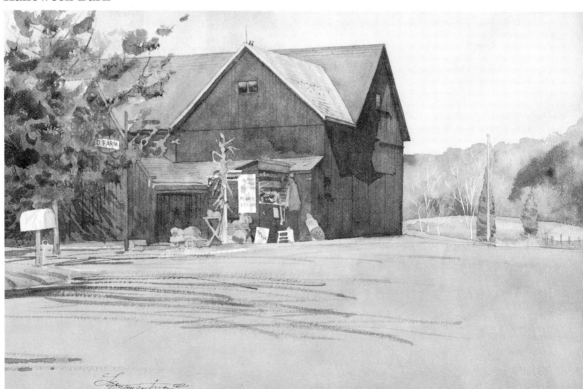

116

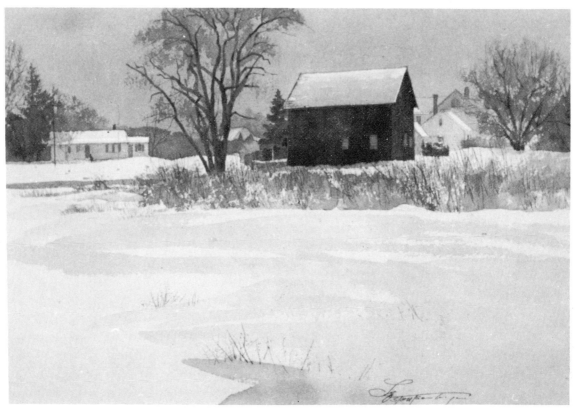

Guilford Barn

Three barns that produce unique picture-making problems

The Chittenden Farm has a nice character about it. Even though the barn buildings are slowly crumbling, there is a grandeur about this place nestled in the hills of the Nutmeg State that makes it a favorite subject. Its quiet solitude makes me want to return to it again and again.

Halloween Barn is a painting with its composition determined for the most part by my limited access to it. There wasn't much room to pull off the side of the road with the car, so I was closer to the subject than I usually like to be. The barn is owned by a retired physician who is himself an artist. In the fall he sells his work to passing motorists. When I painted this, it was a few weeks before Halloween, so there were many pumpkins cleverly decorated by the good doctor.

Guilford Barn is a subject painted on a dark winter's day when all the parts seemed to fall into place easily. The willow on the left has a marvelous shape, and the ranch house seems out of place and incongruous near the austere and lonely barn.

When these barns were newly built many years ago I'm sure they were status symbols for their time. These three barns and the ones on the other pages are entirely different from one another, and yet they all have a character to them that places them in this general New England area. An Iowa barn would be as unlike any of these as a Russian church differs from an Italian cathedral. The subject matter one chooses to paint is probably the least important aspect of painting. What the painter says about the subject is all-important.

117

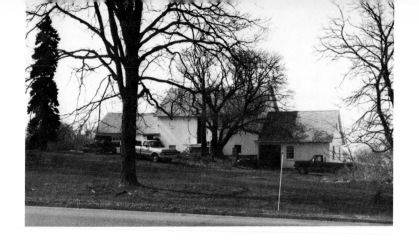

Although this could be considered to be an interesting photograph, I feel that the painting below of the same subject (painted from the same location where the photo was shot) is more exciting. You'll note that in the painting the eye level is raised to help place more emphasis on the barn.

The long diagonal line of the road's edge at the bottom of the picture was left out in the painting because it tends to cut the picture off at that point.

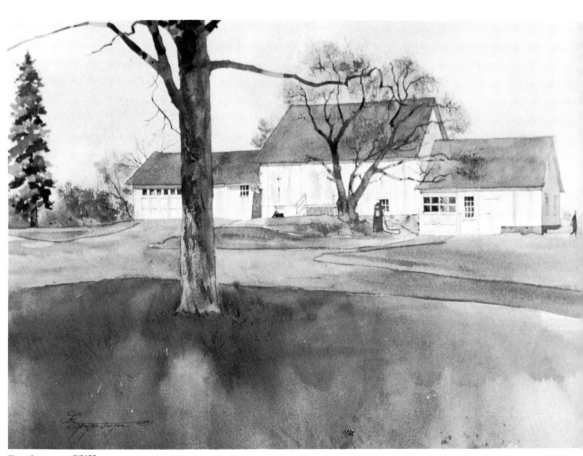

Spring at Hilltop *Collection, Ric Daskam*

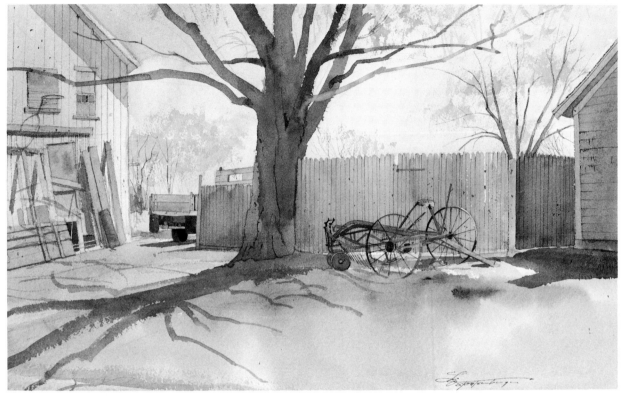

Madison Farm

Collection, Dawn Stoutsenberger

The side of the barn laden with farm paraphernalia, the rake, the truck, and the old oak tree, all tell a story. The thing that made me want to paint the scene was the incongruous look of the contemporary fence used in juxtaposition with the other objects.

I found this subject only after driving around for an hour or so. The search, I feel, was worthwhile.

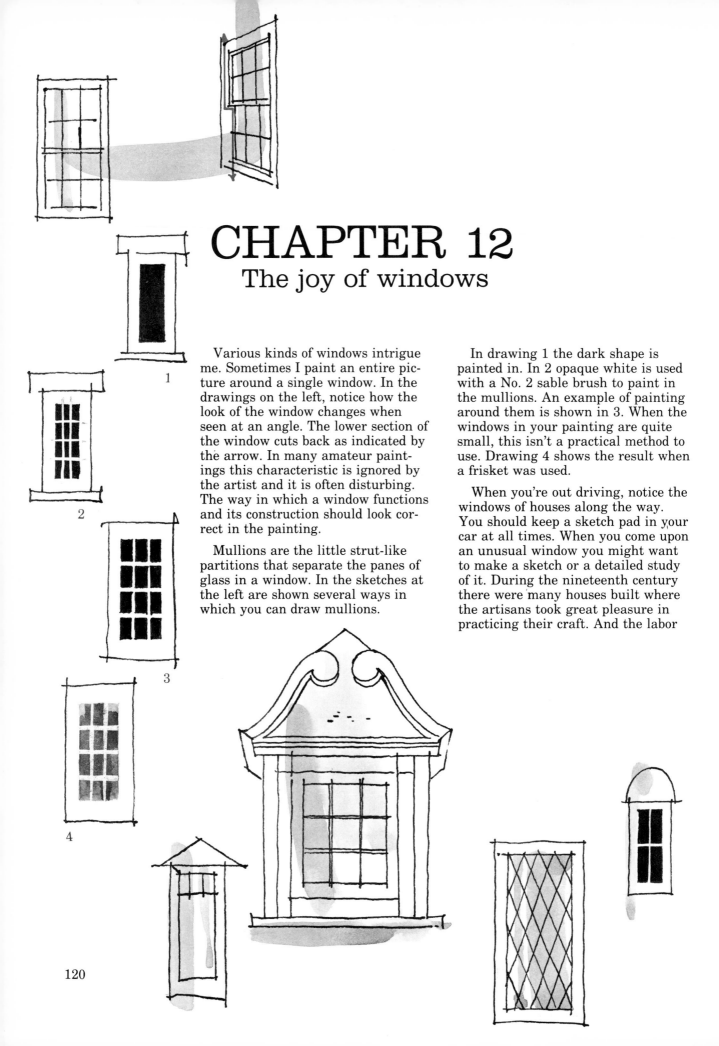

CHAPTER 12
The joy of windows

Various kinds of windows intrigue me. Sometimes I paint an entire picture around a single window. In the drawings on the left, notice how the look of the window changes when seen at an angle. The lower section of the window cuts back as indicated by the arrow. In many amateur paintings this characteristic is ignored by the artist and it is often disturbing. The way in which a window functions and its construction should look correct in the painting.

Mullions are the little strut-like partitions that separate the panes of glass in a window. In the sketches at the left are shown several ways in which you can draw mullions.

In drawing 1 the dark shape is painted in. In 2 opaque white is used with a No. 2 sable brush to paint in the mullions. An example of painting around them is shown in 3. When the windows in your painting are quite small, this isn't a practical method to use. Drawing 4 shows the result when a frisket was used.

When you're out driving, notice the windows of houses along the way. You should keep a sketch pad in your car at all times. When you come upon an unusual window you might want to make a sketch or a detailed study of it. During the nineteenth century there were many houses built where the artisans took great pleasure in practicing their craft. And the labor

1

2

3

4

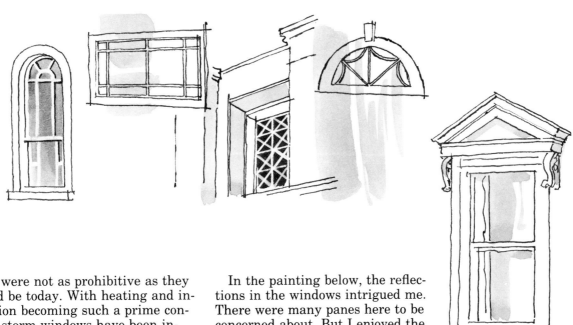

costs were not as prohibitive as they would be today. With heating and insulation becoming such a prime concern, storm windows have been installed, often at the expense of the more aesthetic, ornate design of the original. But there are a number of examples still available, so get out there and look for them. The search can be as much fun as the discovery.

In the painting below, the reflections in the windows intrigued me. There were many panes here to be concerned about. But I enjoyed the challenge of painting each one. The reflections of the tree branches provided me with a connection between the various panes, in spite of the fact each pane stands by itself almost as a small, individual study.

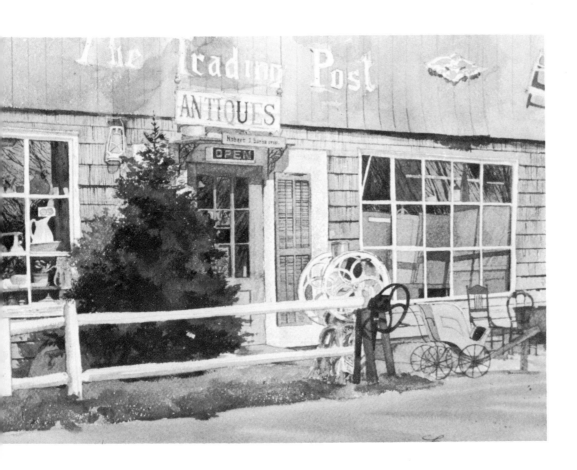

CHAPTER 13
Old buildings never die . . .
they just become museums, or antique shops, or historical societies

Once you have an understanding of perspective and no longer fear it, you'll want to draw everything in sight that tests this knowledge. You'll find plenty of models all around you.

The picture above was painted in Stony Creek. These buildings are fine examples of the architecture of the past. A 19th century house is on the left and an 18th century structure on the right. The old mansion below has been beautifully restored and now serves as a museum. Visitors are welcome several days each week.

Old buildings are fascinating and fun to sketch. I've spent hundreds of hours drawing from live human models. I don't regret any of this experience. But the frustrations one endures working from a form that doesn't remain quite motionless makes me appreciate drawing from one that doesn't move. Oh sure, you must deal with the changes in light, but I find this is an easier problem to cope with.

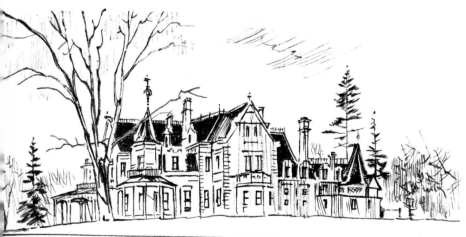

Lockwood-Mathews Mansion Norwalk, Conn.
Union Trust Co. Collection

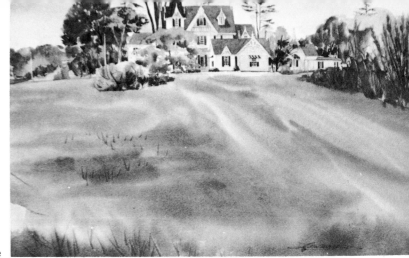

The Mang's House

The Mang's residence above is another Victorian house in Branford which has a tasteful elegance about it that I've tried to capture in this painting. Notice how I've painted this house from a view requireing a minimum of perspective knowledge. Also, the placement of the house high on the paper gives the building a dramatic emphasis.

The Townshend house painting was a commission with somewhat unusual conditions. Mrs. Townshend asked me to paint the house using several different views in the same painting. I settled for three. It probably would have made sense to work from photographs, but I worked entirely on location, from my car. The building is a magnificent example of the period, and I enjoyed doing the assignment.

This type of arrangement is rather difficult to deal with because of the split interest. Of course, you cannot handle the composition as you would in a more average approach to painting. It's essentially a montage where the various sections work as a single unit, yet each part must be able to stand on its own.

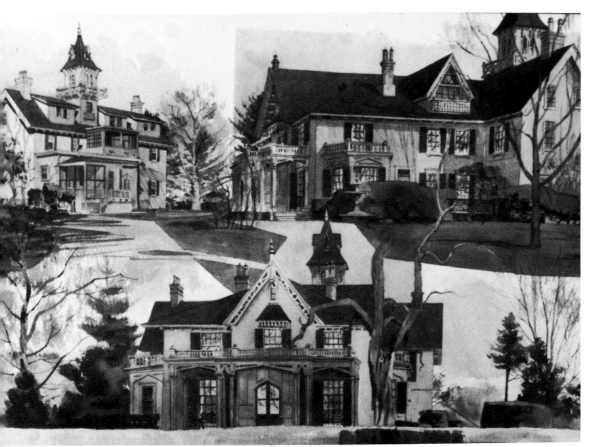

The Townshend Residence

The Historical Homes Series

The Union Trust Company has branch bank offices in many towns in this area. I was hired by the bank to do a series of paintings for bi-monthly calendars to be sent to their customers. After painting over twenty watercolors, we ran out of homes that qualified to be a part of the series. The examples shown suggest the variety of work involved in the project. The originals were painted in full color.

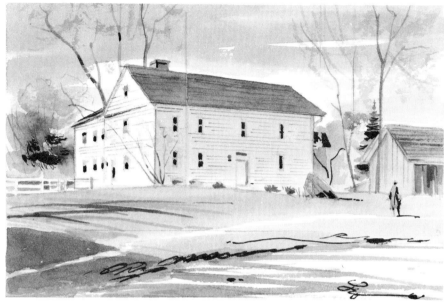

The Eells-Stow House, Milford, Connecticut.

Built by Captain Samuel Eells around 1685, it is now owned by the Milford Historical Society.

Keeler Tavern, Ridgefieler

This is one of Connecticut's most historic landmarks. Originally erected prior to 1733 as a home, it became best known in the years 1772 to 1907 as a tavern, serving weary travelers between New York and Boston. It was also the town's first post office.

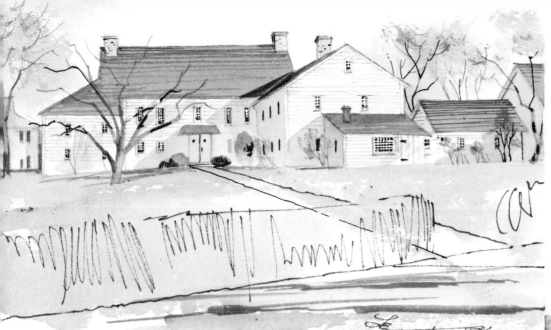

The Old Morris House

This is the house from which Morris Cove, a small town near New Haven, derives its name. The many additions to the house over the years made it a rambling affair. It was a problem to include the entire house within the composition.

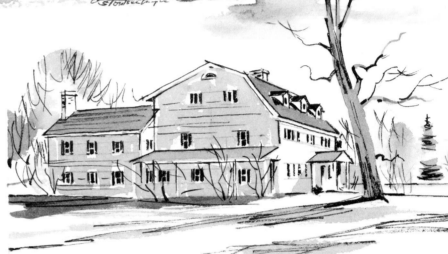

The Lambert House

The Lambert House above was built in 1724 in Wilton, Connecticut. It served as a station on the "underground railroad," the route used by slaves escaping from the South to New England and Canada.

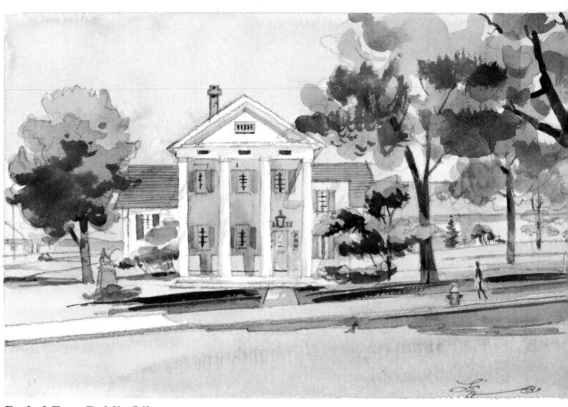

Bethel Free Public Library

A classic example of Greek Revival architecture, this building was constructed as a home in 1842 by Seth Seelye. The building now serves the town of Bethel, Connecticut as its public library.

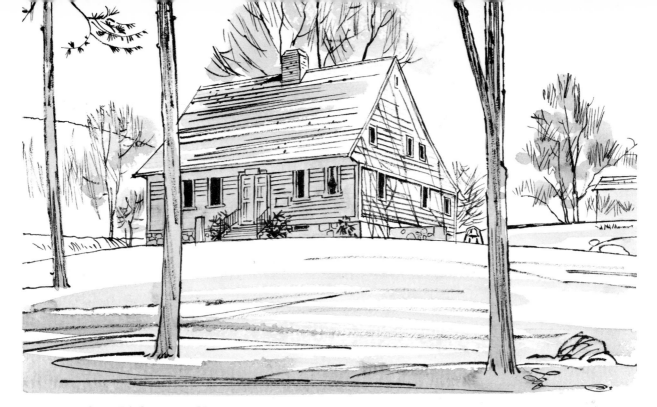

The Jonathan Dickerman House

Jonathan Dickerman House rests in the shadow of Hamden, Connecticut's "Sleeping Giant," a high cliff-like hill. The house was built about 1770.

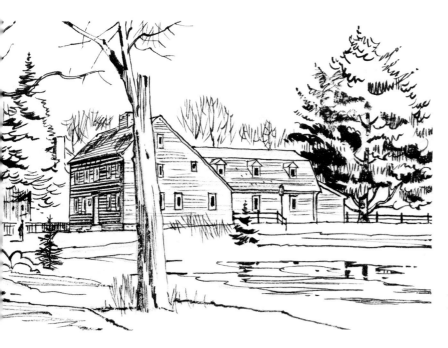

The Bates-Scofield Homestead

Bates-Scofield Homestead, Darien, Connecticut, was built in the 1730's. The massive central chimney serves four fireplaces. It is now the headquarters of the Darien Historical Society. I couldn't resist including the large puddle in the foreground that came from melting snows.

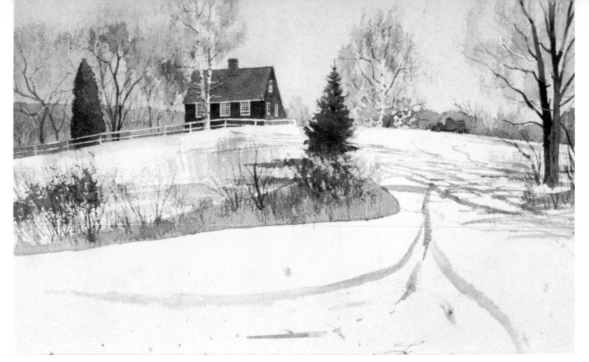

In this view you see only the upper floor of the two-storied house. It's a salt box in Guilford with an old decaying auto in the yard, barely visible on the right. To me this picture epitomizes winter in Connecticut.

The building below is in South Casco, Maine. The place served as a coach stop many years ago. One of the old timers living nearby generously gave me an account of its history while I was painting.

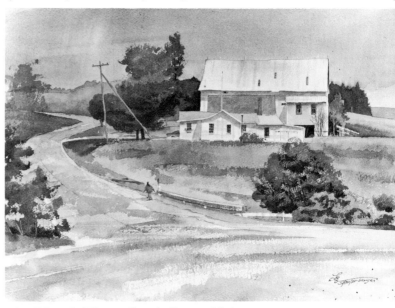

The Murch Place, South Casco, Maine

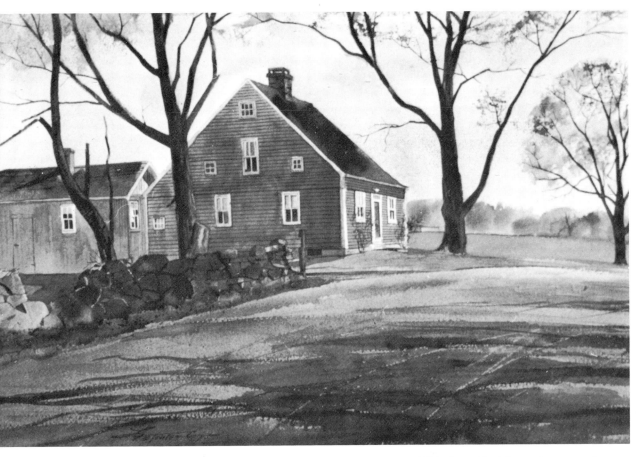

This fine old eighteenth century house stands proudly on one of the back country roads of North Guilford, Connecticut. The soft curvature of the road as it comes toward us is emphasized by the cast shadows of the trees.

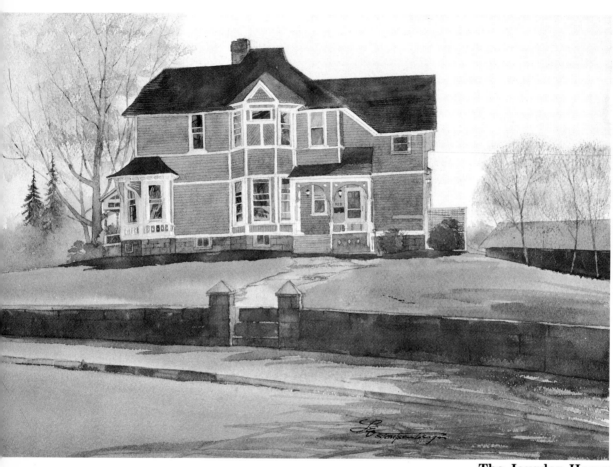

The Jourdan House

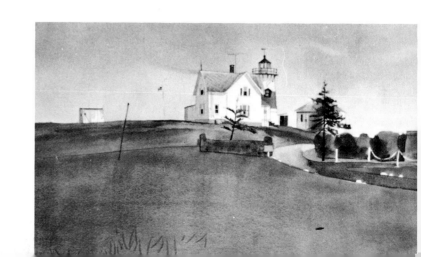

130

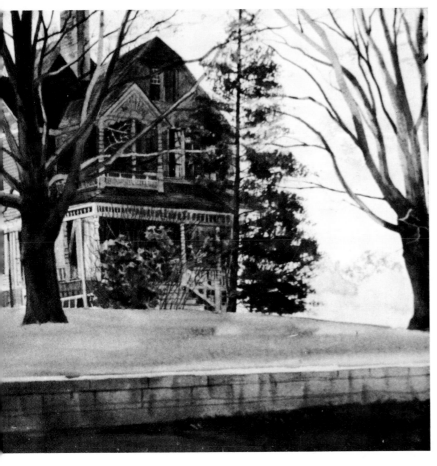

The Jourdan House, in its profile view on the far left, offers the painter a compelling subject. I find the variations of the negative shapes in this picture fascinating.

Next to it is shown a three-quarters front view of the same house. I was overjoyed when I learned this grand old structure had been saved and the new owners were willing to restore it.

The two lighthouse paintings on the opposite page are two views of Lordship Light in Stratford, Connecticut. What great fun to paint! Like the covered bridge, the future of the few remaining lighthouses is bleak.

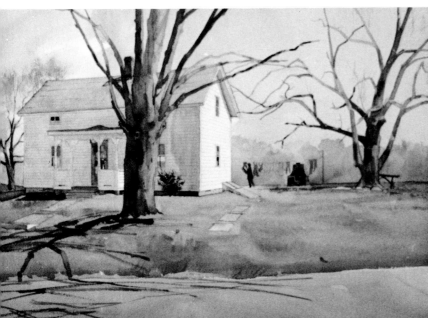

There's nothing particularly admirable about the architecture of this house. But I liked the look of it; also, it was in a convenient spot to paint, so I painted it. I like the play of the shadows, and the ornate carpentry work gives it a special character. And of course the tree contributes an important element to the picture.

131

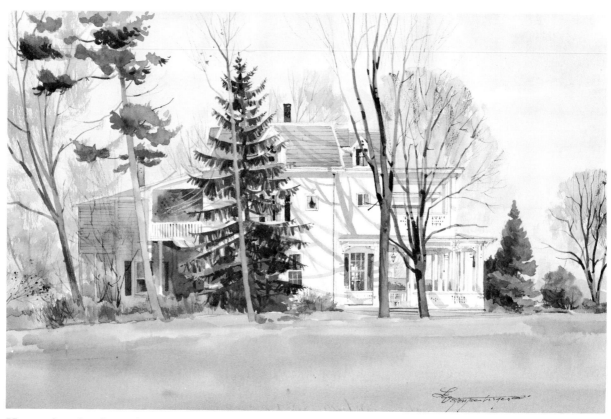

House by the Sound

Homes like this, with an advantageous panorama of the water, are common all along the coast of New England. These houses seem to have been built within a few years of each other. Although they are Victorian in style, there are a remarkable number of differences in their architecture. I've never seen two Victorian houses that are exactly alike. I chose this side view of the house for its relative simplicity.

East Pearl Street Parsonage

This house stands across the street from a Methodist church in Fair Haven, Conn. It stands amid many houses that are in the process of deteriorating. What influenced me to paint the subject was the unique brick structure design that runs entirely around the house. Of interest also is the way the street begins to go out of the picture but swings back in to include stores and houses in the background.

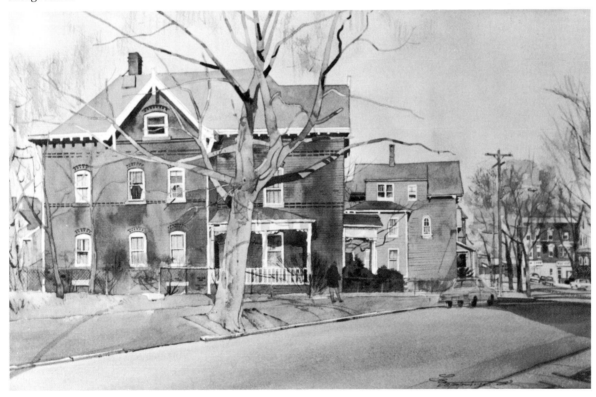

CHAPTER 14
Boat yards

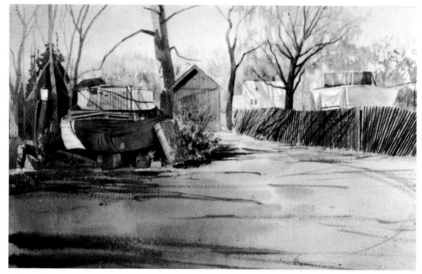

Topsy

It's not much fun going to boat yards in the summertime to paint. They're too busy. But in the middle of winter or late fall they can be fine subjects and a great storehouse of interesting painting material.

Branford has several yards and by now the owners are used to seeing me sketching in my car. Sometimes owners of boats come over and offer to buy a painting which has their boat in it. The boats, with their canvas tarpaulins covering them, make engrossing shapes. There is always a great variety, and the drapery of the heavy tarps with the curved, sweeping lines of the boats can be more than enough of a challenge.

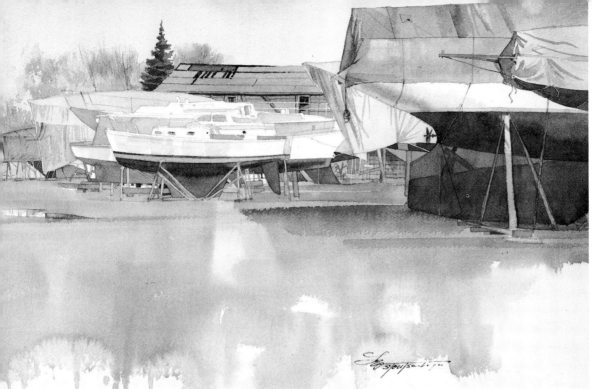

Dutch Wharf Boat Yard

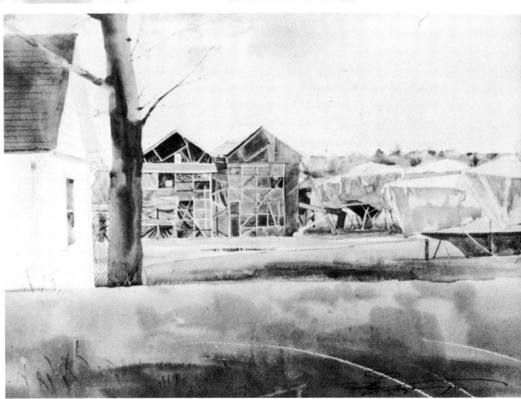

Winter at Dutch Wharf

Covered Boat at Tylers'

135

Look in any direction and you'll find a subject to sketch or paint. You don't have to paint a finished picture an old rusted propeller, a discarded steering wheel, parts of anchors. Any one of these or several together, can give you a reason for drawing. Each time you look at that sketch or painting you'll relive the experience of being there.

Every boat yard will have shiny, new boats in great abundance. But, like houses, you'll find that the old, weather-worn vessels make better subjects. Although I rarely add figures, you might want to include some of the owners who are invariably scraping or painting their "mistresses."

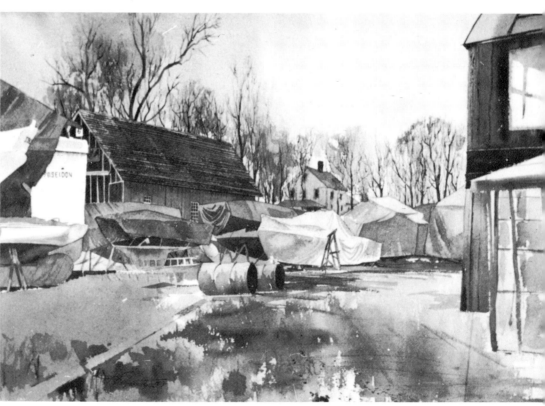

After the Rain

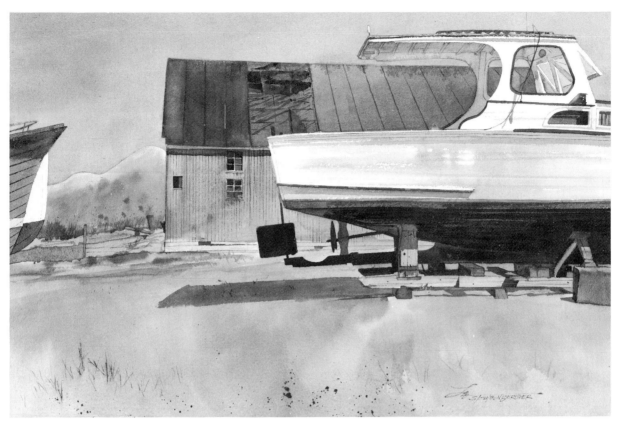

Wylies' on the Housatonic

Collection, Dawn Stoutsenberger

A back view of this old,
abandoned relic as it stands with
a ladder across its stern makes a
poignant study and a graphic
reminder of
Gladys at Tylers'

CHAPTER 15

Retired
Collection, Craig Cope

Gladys
Collection, Mrs. Lee Pape

It may seem rather strange to give a name to an old discarded pickup truck. But Betty and Elmer Tyler refer to their remnant of the past, now resting in their back yard, in such loving terms.

When the Tylers were married in the late thirties they bought the truck and proceeded to haul stones to build the seawalls of their yard. When Gladys gave out they just left her where she died. Gladys is now a part of the landscape. The rust that covers her body blends in with the fauna and wild flora that abound in the yard.

Thanks to Betty and Elmer, I've spent many productive and pleasant painting hours in their yard.

CHAPTER 16

Making several paintings from one

When I asked John Moss if I could sit in his greenhouse during the Christmas holidays and paint he said, "Sure, as long as you don't mind my customers kibitzing over your shoulder. Besides," he said, "it'll give my place some class to have an 'artiste' working here." John's place already has class. He doesn't need a watercolorist to give it more. When painting on location it always is a good idea to get the cooperation of the people whose lives you inconvenience.

I worked for many hours on this painting. After I'd finished it became obvious the picture was busy enough to become more than one painting. My mother-in-law likes it the way it is, but I've used it here as an example of a possible means of producing a number of different works.

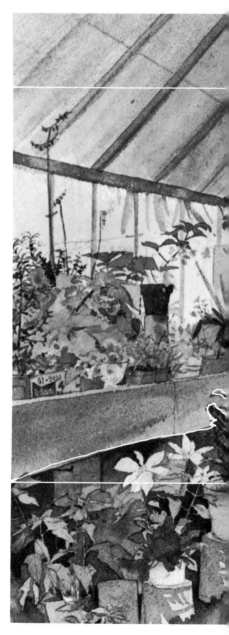

Christmas at Platt's Seeds

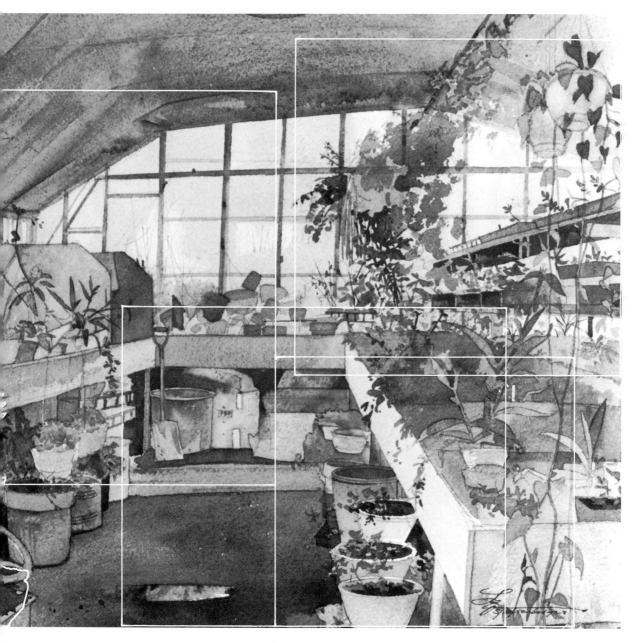

Collection, Mrs. Ermina Bailey

141

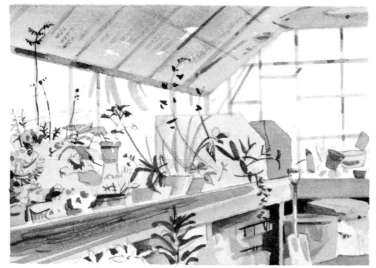

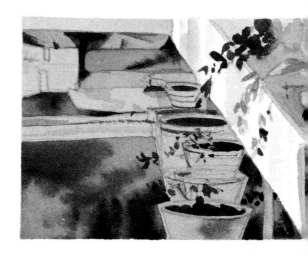

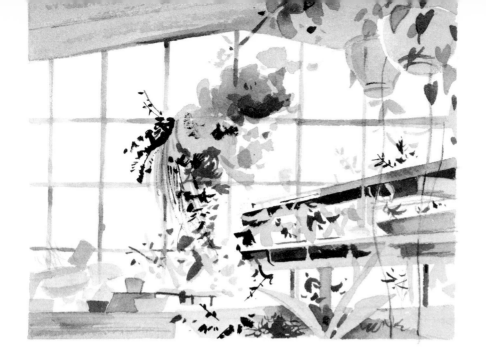

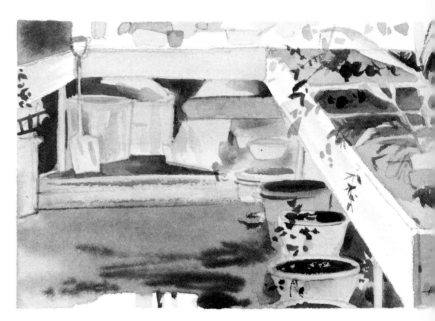

Flowers are delicate and difficult things to paint. While working on this painting I was amazed at the brilliant colors that my tube paints could not match. When this happens you find yourself falling back on controlling your values to give the illusion of what you want. Dyes or colored inks might achieve more brilliance, but it's important to remember we cannot duplicate the colors we see. All an artist can do within the means of his limited palette—no matter how many colors he uses—is to suggest the feeling of the scene he is painting.

CHAPTER 17
Demonstration

This painting was selected for a demonstration because it is fairly simple. The perspective is uncomplicated, and it can be painted with six or seven colors. Try it.

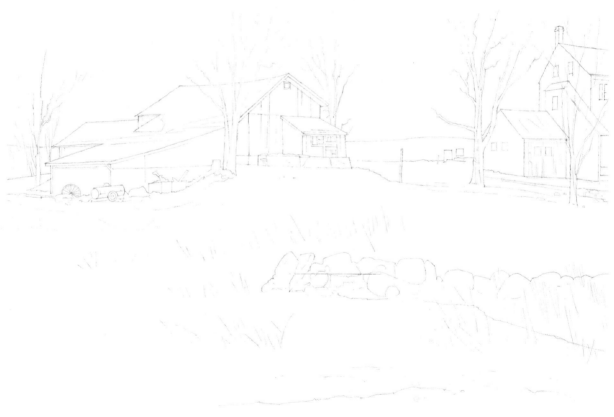

1 The outline shapes are drawn in carefully and precisely.

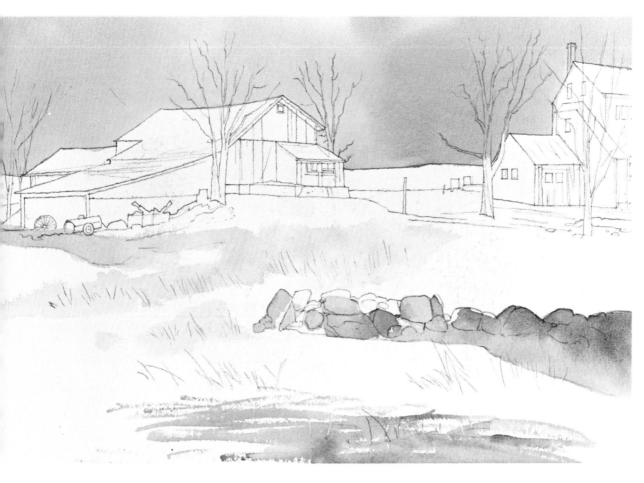

2 Begin with the sky. This is a wet wash using cobalt blue grayed somewhat with cadmium orange, and a touch of cerulean blue added. While this is drying, skip down to the colors you see here. The stone wall is painted like the demonstrations of rocks shown earlier, (page 58). Some dry brush foreground shadows are applied in the lower right.

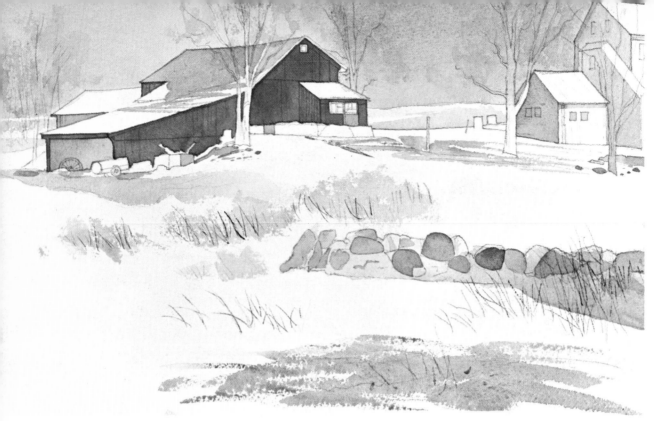

3 At this stage I drew some more with the pencil. When the sky is dry to touch you're ready to draw the branches of the trees. When you become skilled enough and increase your confidence you'll be able to paint these branches without drawing them in pencil first. At this stage I've added a wash of gray to the roof of the barn and the shadow on the side of the house. I mixed these grays using the primaries. The other areas are carried a bit further using smaller brushes to suggest texture. I then painted the barn. I used cadmium red with a touch of thalo green to gray it slightly and then, while the paint was wet, added touches of alizarin crimson.

4 All the details are added now. Notice how some things have been left to your imagination.

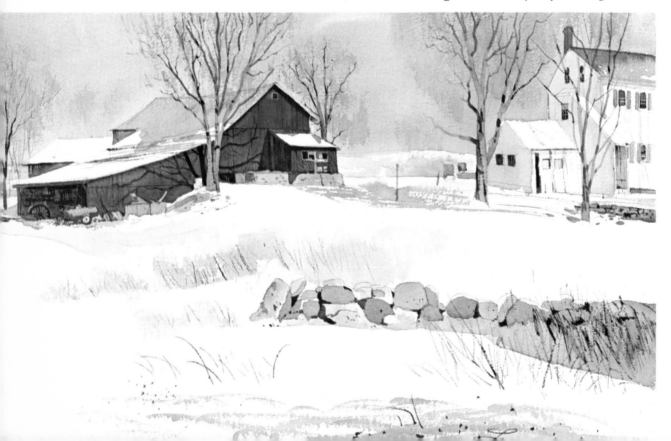

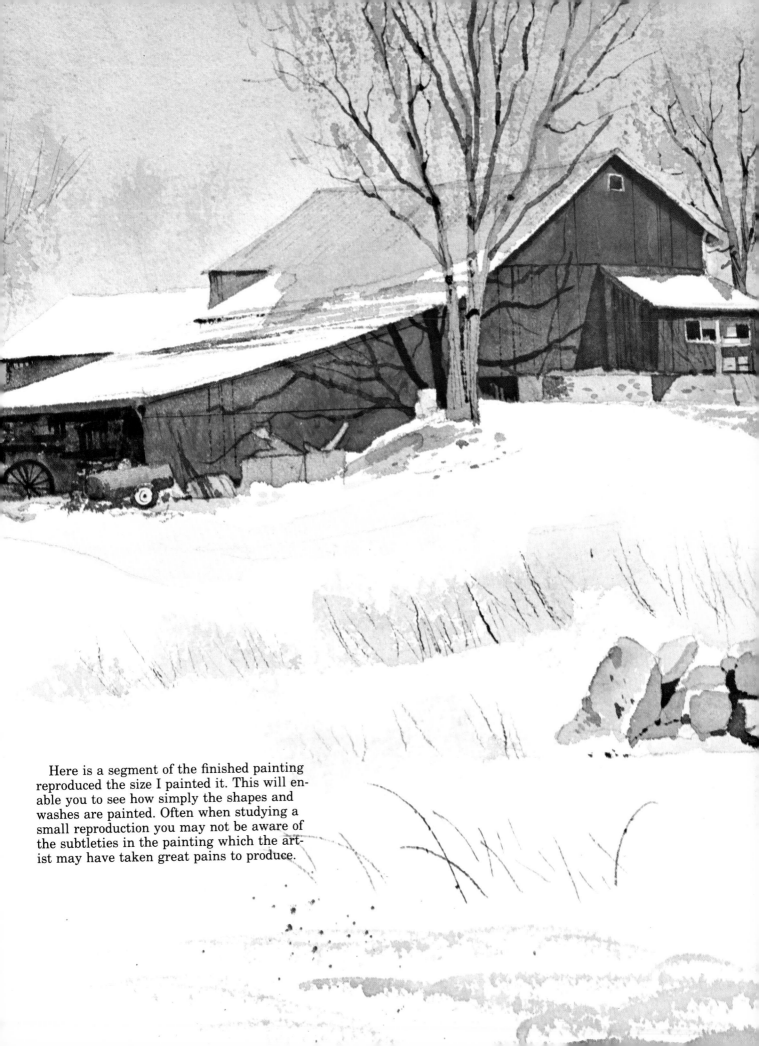

Here is a segment of the finished painting reproduced the size I painted it. This will enable you to see how simply the shapes and washes are painted. Often when studying a small reproduction you may not be aware of the subtleties in the painting which the artist may have taken great pains to produce.

A demonstration in
Textures

A student once said to me, "You're always talking about texture. Why is texture so important?" I wasn't sure just how I should answer him, but I pointed out we live by our senses. And one of these is the sense of touch. People can hardly keep from touching everything within reach. Gift shops have to put up signs that read "Please do not touch." This sensitivity to surfaces can be exploited by the painter.

An old barn with a great variety of surfaces including shingles, several kinds and conditions of worn and painted glass, and masonry makes a fine subject. If you paint the picture in separate stages as shown in the examples here, you'll find it a relatively simple subject.

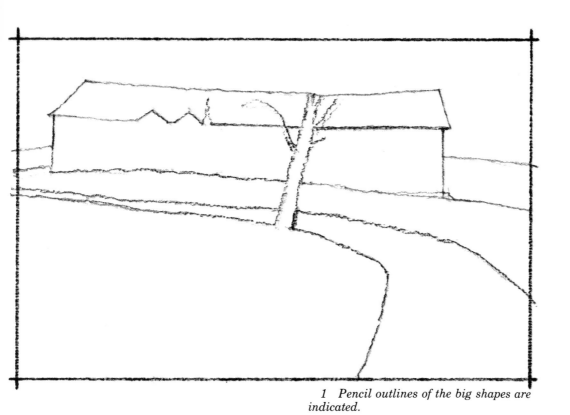

1 Pencil outlines of the big shapes are indicated.

2 The sky is painted in with a wet wash. Then both grassy areas are painted, using wet washes and keeping color fluid.

149

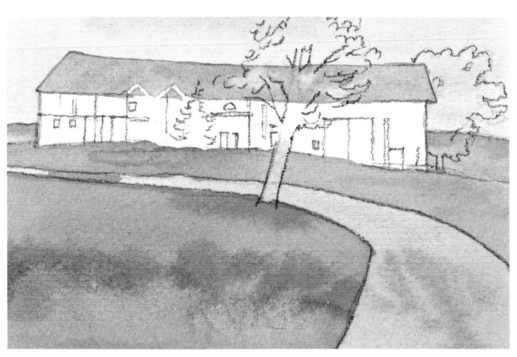

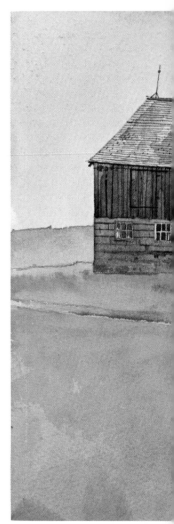

3 Next, I drew the roof line and add color to the long, horizontal shape of the roof. The background in light green is added on the left and the right. Moving down to the roadway I paint with a wash that is gray violet, a mixture of ultramarine and cadmium red.

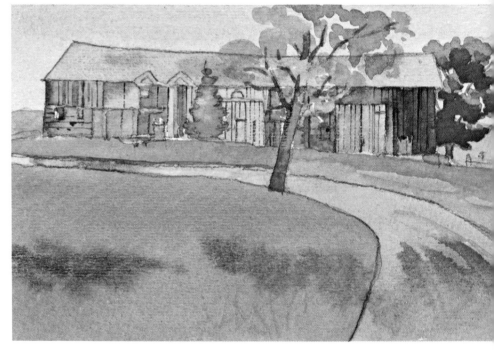

150

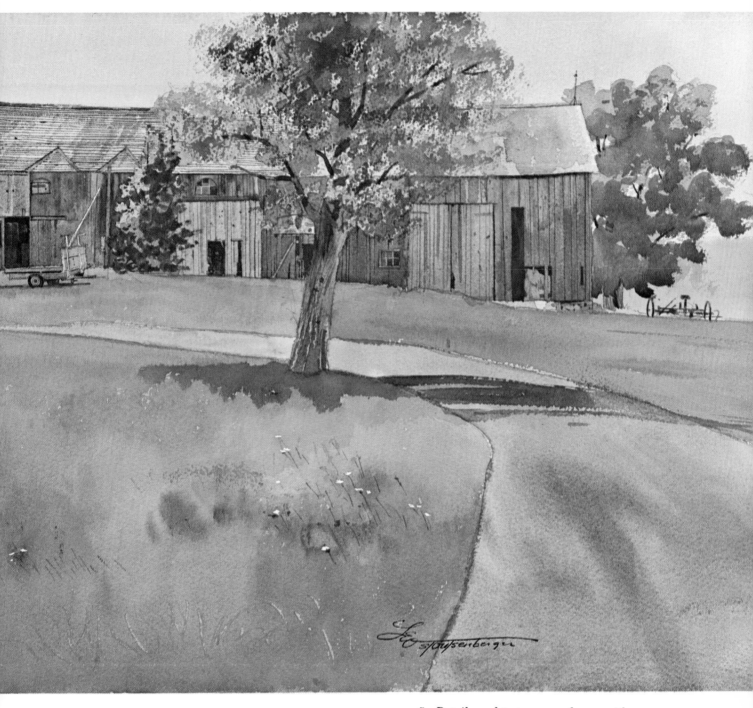

5 Details and textures are drawn with
a No. 2 sable brush. Wild flowers in the
foreground are added, using white
gouache and some cobalt blue and white.

4 The foreground tree is brushed in
with a warm gray, using mostly the pri-
maries, and varying the color to suggest
reflected light from the ground. Now the
pine tree is painted by mixing thalo green
with burnt sienna. The side of the barn is
drawn in detail with pencil. After this, the
various sections of the barn siding are
painted with grays and gray violets.

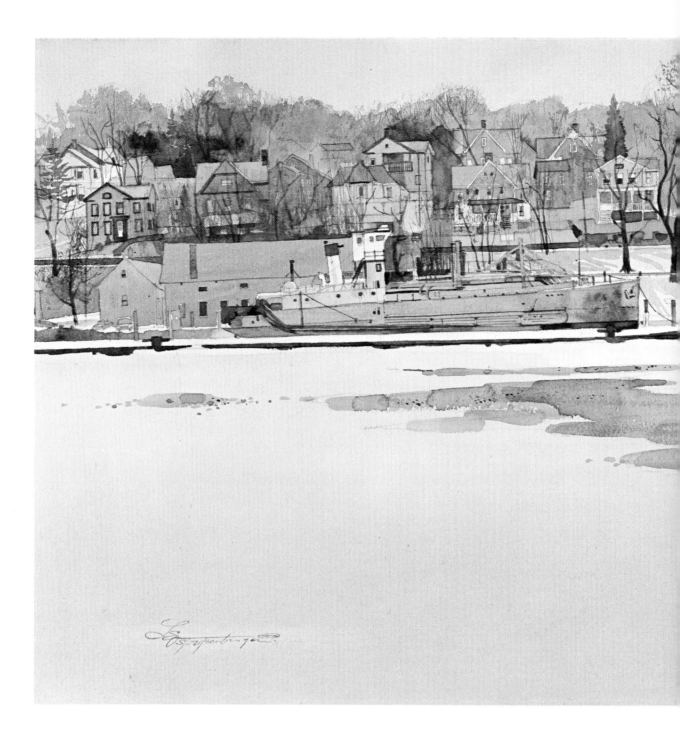

This series of eighteen watercolors started quite by accident. One day, when driving home from my classes, I came to a draw-bridge which had become inoperative and was blocked off with a detour sign in front of it. This meant I had to use a circuitous route and another bridge to get home. While on the detour I passed through an area I had never seen before. I thought, "This is an interesting area. I'll have to come back here on the weekend. There must be two or three watercolors here."

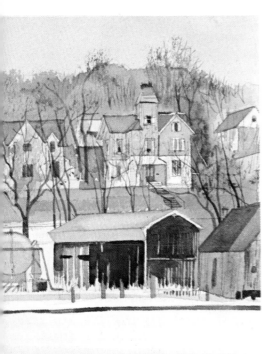

CHAPTER 18

The
Fair Haven
Series

When I drove to the spot the next weekend it was a cold, bleak winter day. I decided to paint the old Grand Avenue bridge. One reason this area had such painting possibilities was because there was a large, cleared space which had, at one time, been a scrap metal dealer's storage lot. It had been completely taken down and moved to another location. The empty space made it easy to park and move the car around so as to be in the best position to paint each picture.

While painting the bridge I found myself looking behind and all around. I thought, "Hey, there might be more than two or three paintings here!" I completed the bridge. The following week I could hardly wait to return to my spot and begin another painting. The next week it snowed, but no matter. I took my portable studio to the site and began working on the scene reproduced above. It is an old oyster boat at anchor with a backdrop of houses. I worked on the painting on three successive mornings totalling about seven hours. The following week I looked forward to going back to the site and starting another painting.

153

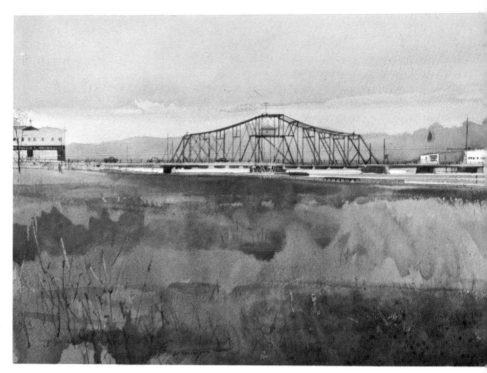

It didn't occur to me until after I'd finished about four paintings that I should try painting a complete series of pictures that would take-in a 360-degree panorama.

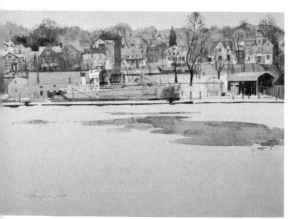

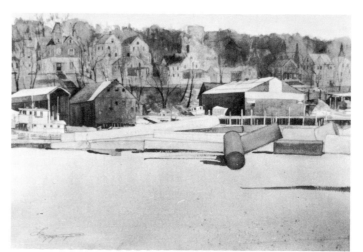

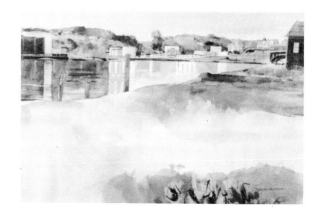

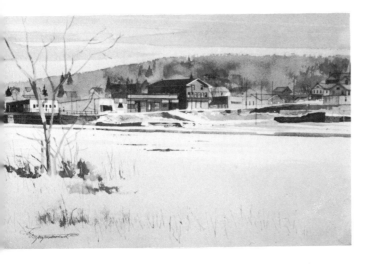

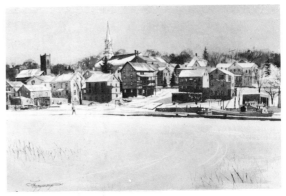

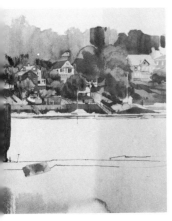

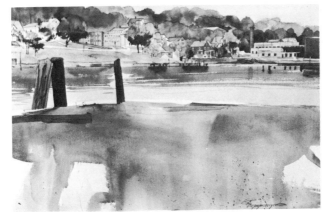

Opportunities don't come along like this very often. A little bit of luck often plays a part. But you must be willing to take certain risks. Shortly after I'd finished the series, my car had a succession of flat tires. We discovered that they had become saturated with bits of metal imbedded in the ground left behind by the metal refuse company.

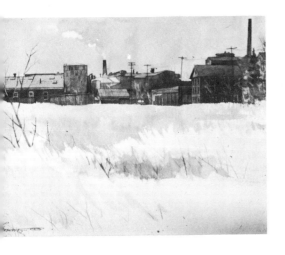

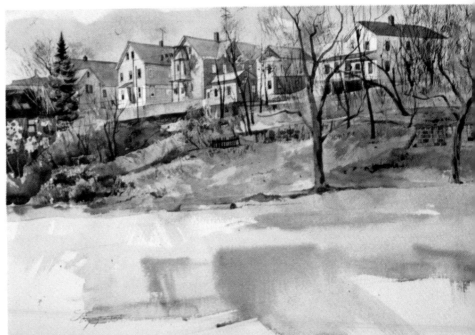

These eighteen paintings were purchased shortly after I'd completed the series. They are now in the private collection of Richard K. Mazan of New Haven, Connecticut.

Because the works were done over a several months' period there is a change of seasons from mid-winter to early spring.

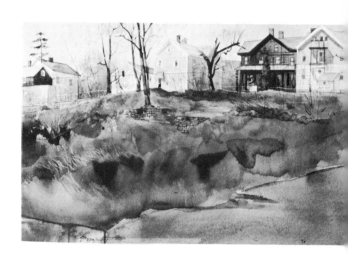

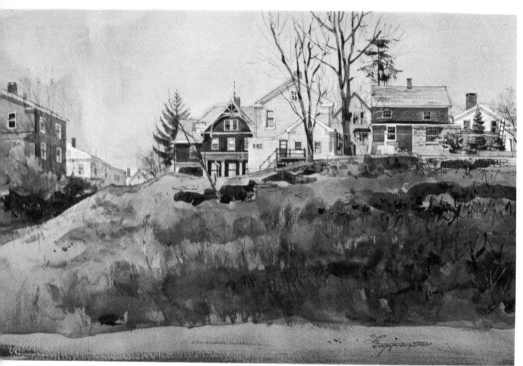

156

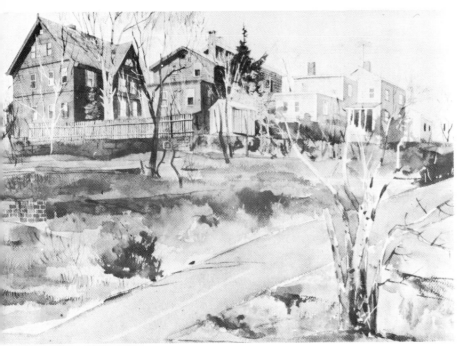

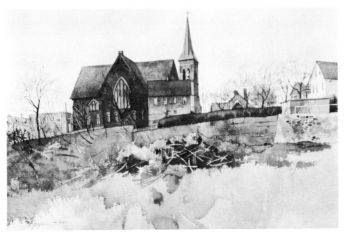

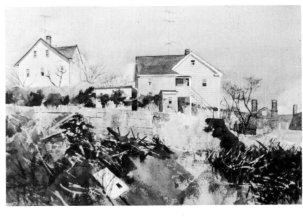

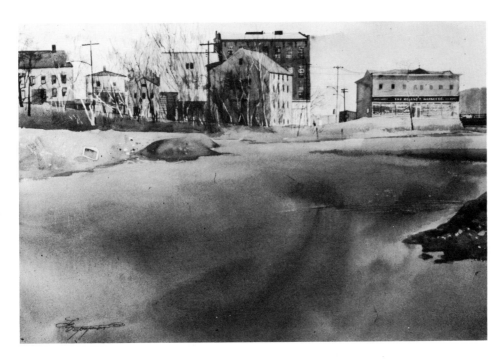

157

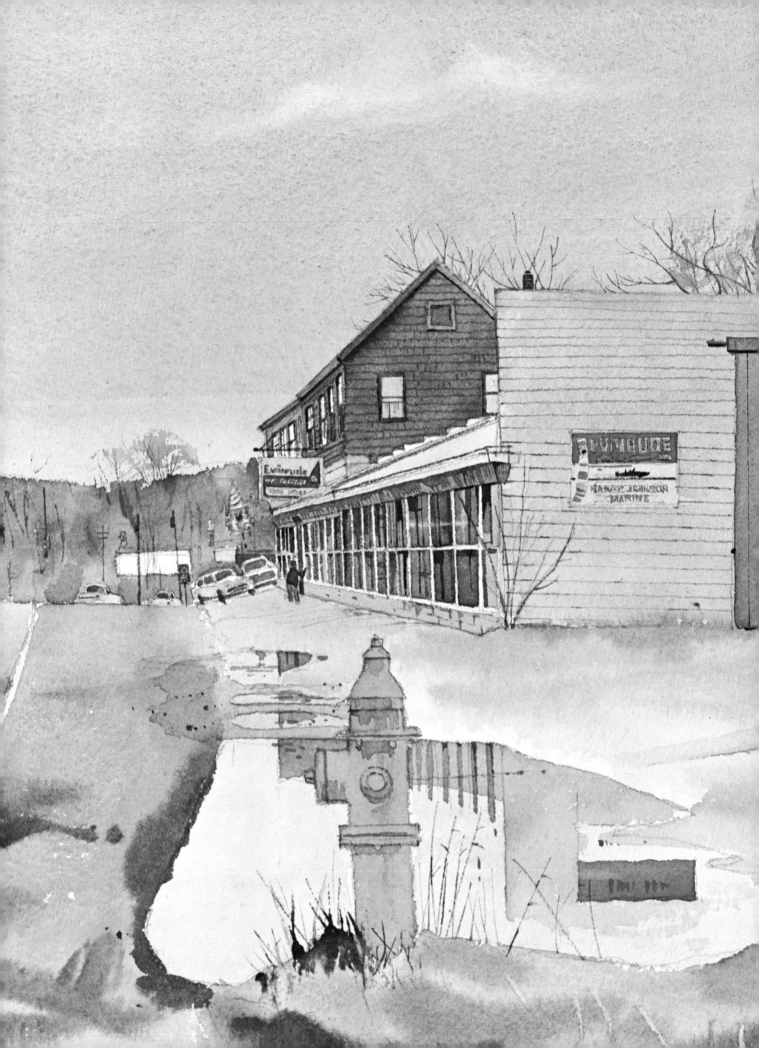

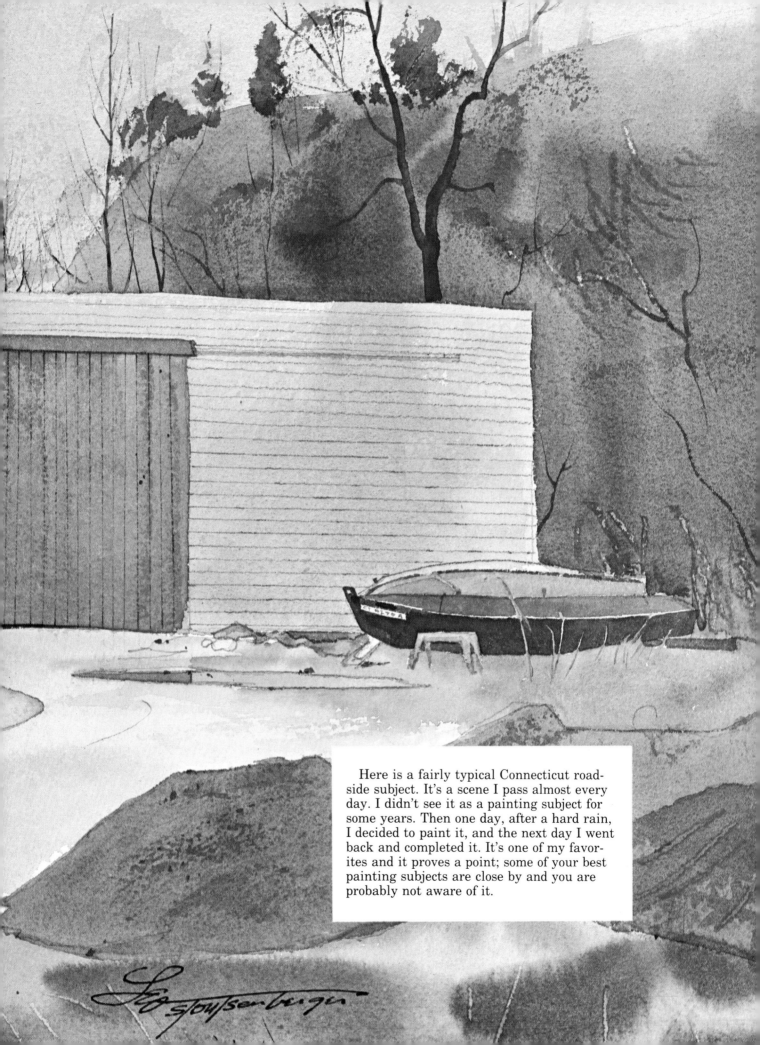

Here is a fairly typical Connecticut roadside subject. It's a scene I pass almost every day. I didn't see it as a painting subject for some years. Then one day, after a hard rain, I decided to paint it, and the next day I went back and completed it. It's one of my favorites and it proves a point; some of your best painting subjects are close by and you are probably not aware of it.

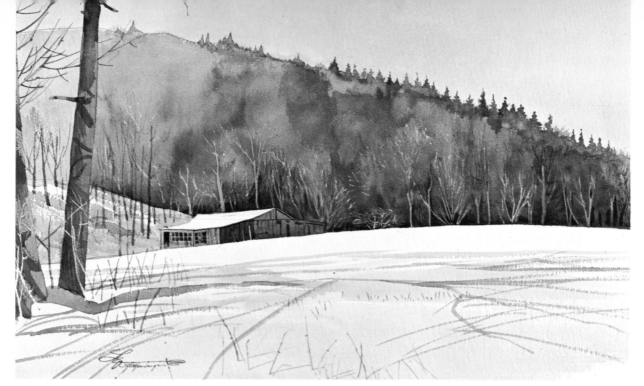

Winter on Route 77

CHAPTER 19
Contrast

Sometimes I'm called upon to judge regional painting shows. This affords me the opportunity of seeing a great many watercolors. Usually these paintings all suffer from the same malady, *not enough contrast.* To overcome this difficulty get used to looking at the subject in terms of values before considering the color. A good plan is to draw first at a reduced scale using black and gray markers.

Claude Croney in his books talks about the three-value system. Rex Brandt usually diagrams with four values. Whatever system you prefer, the point is obvious; you should attract the viewer to the picture by its pattern.

Here are four paintings to illustrate the point of building a picture with strong value patterns. One of the oldest precepts in painting is: dark against light, light against dark. How simple that is, but how often we forget! In the painting above the strong convergence of the dark mass tends to lead the viewer's gaze out of the picture. However, the strong dark and light pattern at the left brings your gaze back into the composition.

The painting directly above has subtle, soft halftones that dominate the composition. But the dark rock and the staccato rhythm of the utility poles give the picture an interesting pattern.

In the painting on the right the darks predominate, leaving a strong pattern of the lights. Contrast provides the dominant interest which holds the various parts of the picture together.

Below, the fence is the most exciting part of the composition. Notice it does not go in an unbroken line from one side to the other. The dark pattern of the fence against the light value is easily seen, just as the white farmhouse against the dark background is immediately visible.

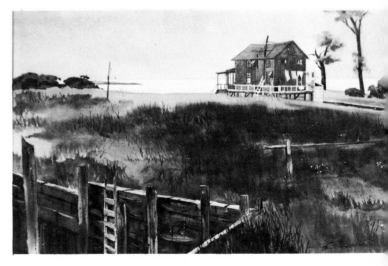

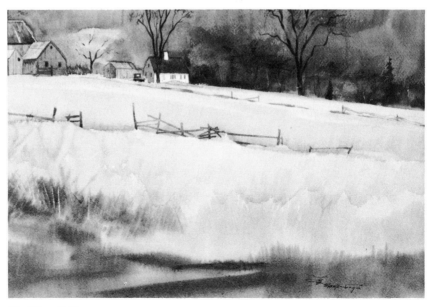

Guilford Farm

one good way to learn
brush control is to start
Painting *around* things

Stony Creek Cemetery

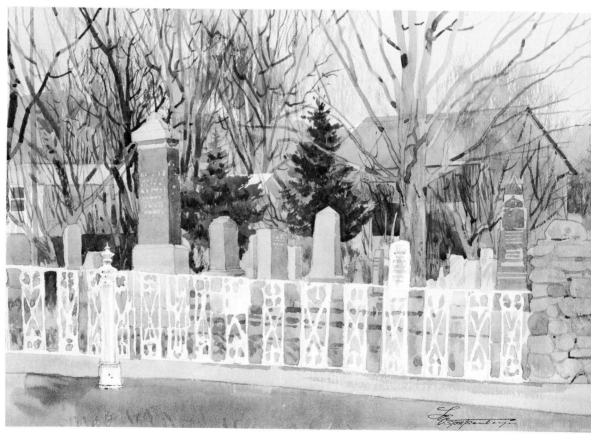

162

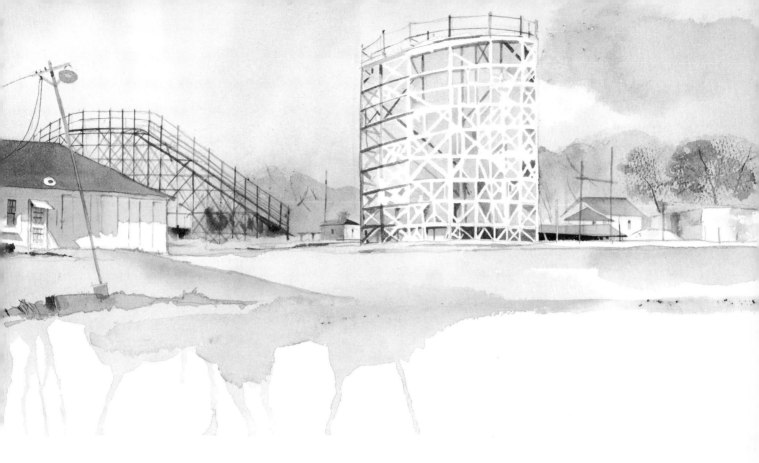

Sometimes when I'm painting on location I forget to bring along the Moon Mask or Miskit. At such times I use the "painting around" technique. When this happens, I like to treat the experience as an opportunity to expand my versatility in using the medium. This gets into the area of establishing a good, healthy attitude in regard to your practice of painting.

When you find an appropriate subject to use this technique, it's important to make your pencil drawing as accurate as possible.

In the Stony Creek cemetery painting, the fence is not as clean and uniformly done as it would have been had I used the frisket. But I like the way the irregularity of the parts of the fence gives it a character that might not've been as effective had masking material been used.

Believe it or not, the roller coaster reproduced above was fun to do. It's somewhat of a minor tour de force, but this kind of project can be a challenge for you if you like to draw for the sake of drawing.

You won't want to attempt a subject this complicated at first. Painting around some simple, rectangular shapes will help you develop your technique, and with practice you'll build up your confidence to tackle more complicated subjects.

It can be argued that as long as there are materials like Moon Mask why do it the hard way? I don't look at it like that. If you want to be a complete painter you should always be in command, even on those occasions when you left the "crutches" at home.

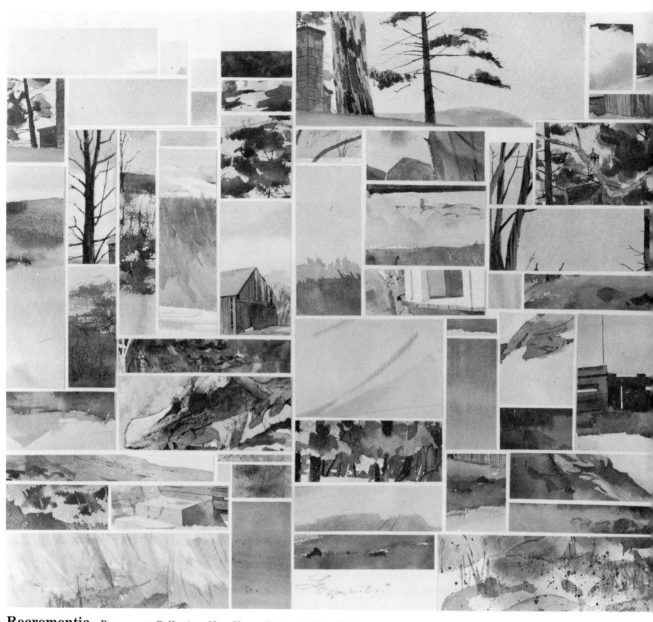

Recrementia *Permanent Collection, New Haven Paint & Clay Club, Inc.*

164

CHAPTER 20
Don't throw away your old watercolors!

One day, while going through a stack of pictures and deciding which should be burned, I concluded that parts of some had interesting spots of color, texture, contrast, and shapes. So I cut up many of these old paintings and arranged the pieces into some kind of abstract design on a full sheet of watercolor paper.

After deciding the overall effect was good, I mounted the various rectangular shapes into permanent positions. It looked interesting and I decided it might be worth framing. Later I entered it in the annual Silvermine show in Fairfield County, Connecticut. But what to call it? Since it was a prestigious juried show, a title can sometimes be an important consideration. In my dictionary I found the word, "recrement." It had a certain ring to it. The definition was in two parts: 1 the worthless part of anything: waste, dross. 2 in physiology, any substance, as saliva, secreted in the body by a gland, etc. and then reabsorbed into the blood. . . . So I added the "ia" to it and it became my own word. It was accepted for the show.

I'm not going to imply the title had anything to do with the acceptance, but the show almost always shuns representational paintings in favor of the abstract. It makes an interesting point . . .

Later I entered the same painting in an annual New Haven Paint & Clay Club show. It won a cash prize, and was later purchased by the club for their permanent collection.

In putting *Recrementia* together I admit there was some gimmickry involved. Nevertheless, considerable thought and hard work also played an important part. From experience you learn the creative process works in many and sometimes strange ways.

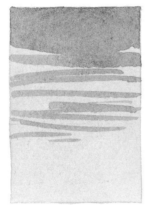

Aquallage

After Recrementia I had the fever, and I did a few more in the same vein. Some friends say I stopped because I ran out of titles. But I really haven't stopped—the search goes on—the search for subjects, ideas and new forms.

CHAPTER 21

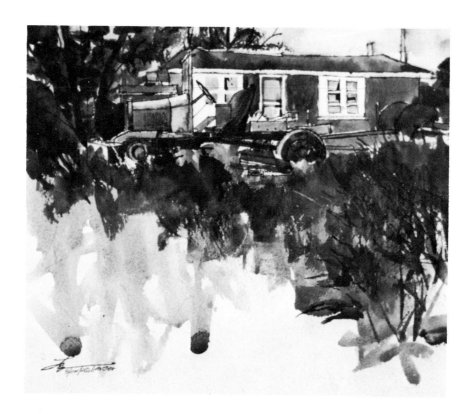

Attitude

It's not easy to always maintain a good working attitude. Sometimes you have to work on it and at it. As a painter you should develop a positive outlook toward all things. Bouncing back after failure is an experience that builds character and makes artists. Can you imagine how difficult it must have been for Vincent Van Gogh to continue painting in spite of widespread rejection or indifference while he lived? Yet the energy and enthusiasm his paintings transmit suggest when he finished one painting he was burning with desire to paint another.

One of the most quoted American teachers on art is Robert Henri. In *The Art Spirit* Henri says: "I find nature 'as is' a very wonderful romance and no man-made concoctions have ever beaten it either in romance or sweetness. Everything depends on *the attitude of the artist toward his subject*. It is the one great essential. It is on this attitude of the artist toward his subject that the real quality of the picture, its significance, and the nature and distinction of its technique depend.

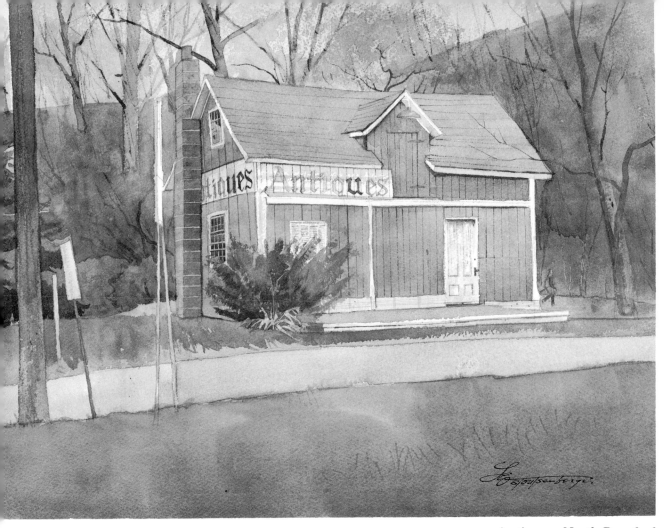

Antiques, North Branford

"If your attitude is negligent, if you are not awake to the possibilities you will not see them. Nature does not reveal herself to the negligent.

"As a matter of fact, the most ordinary subject is in reality a fascinating, mysterious manifestation of nature and is worthy of the greatest gifts anyone may have of appreciation and expression."

Henri also wrote: "We have great periods. Periods when we freshen, become disposed toward health and happiness, move forward into hopeful philosophy. Then comes the stamp of personal whim. Technique becomes a tool, not an objective. We are interested and we have expressions we must make. All things are appreciated with an abundance of humor. There is an association with nature. Something happens between us and flowers in a garden, a communication of gayety, rhythm in the grass understood—something charming in a day's wash hung on the line—a song running through it all. Associations with nature. It's a state to be in and a state to paint in."

169

CHAPTER 22
Choosing a title

One of my favorite pastimes is to read titles in art show catalogs. I make a practice of keeping these catalogs for a long time. Every now and then I pick up one and read the titles.

Here are some typical examples: *Going Home* (this one appeared in four different catalogs) *Forgotten Memories, Prelude to Summer, My Dream, Romantic Renewal, Enigma of Peace, Quietude, Summer Blues, The Garden Path, Gramma Knitting, Nocturne, Edge of Beyond, Needs a Little Fixin', Winter Interlude.*

Once I read an art critic's appraisal of a show. The main thrust of her criticism was directed at the banality of the paintings in the show. She made a special point of criticizing one of the titles, *Done Rovin'* as being typical of the show as a whole. The painting she referred to was an old derelict boat, seen resting on its side at sunset.

The false sentimentality repelled the critic. When you paint representationally it's difficult to avoid this. *But you must!*

Sunsets and palm trees are often chosen as subjects by beginners. They're usually painted poorly. Unless these things are drawn from direct observation, and unless the artist makes his work a meaningful statement, it'll appear hollow and superficial.

Sentiment is to be avoided because it is not permanent. It won't last. Webster defines sentimental as affectedly or superficially emotional; pretending but lacking true depth of feeling; maudlin; mawkish. Influenced more by emotion than reason; acting from feeling rather than from practical and utilitarian motives.

There is a phoniness in sentimentality. Good taste, although hard to define, must have honesty as its primary motivation. Walt Whitman avoided pettiness and triviality at a time when it was the fashion to sentimentalize. The object should not be to *make art,* but to be in the state of awareness that makes art possible or even inevitable.

Obviously, titles have very little to do with the merit of a painting. But they give some insight into the artist's feelings and attitude regarding his picture. And the viewer can be influenced before seeing the work by the title as it appears in the program or prospectus listing the paintings.

As you look through a book of works by some of the Old Masters and the French Impressionists you'll notice how simple and unpretentious the titles are. *The Race Track* by A. P. Ryder, or *The Letter* by Ter Borch. *Interior of a Dutch House* by De Hooch, *The Avenue* by Hobbema, *Chestnut Trees at Jas de Bouffan* by Cézanne, *Sunflowers* by Van Gogh. The list could go on and on, chronicling the simple titles of great paintings of the past. But the titles are not cute or clever. They simply identify the picture!

Contemporary abstractionists tend to go to the other extreme. The following titles all come from abstract and non-objective paintings that were seen in national shows. *Element 32, Untitled, 3 x 3 x 3, Kiku in Rhombic, Number One, 3/71, Focus R-1, Painting for S., Vertical, Electromagnetic.*

A title should be for the purpose of identifying the picture and that is all. You must tie a name to the painting so that it can be properly catalogued or a record made of it. I try hard not to let sentiment affect the titles I use. However, once in a while I slop over the edge, too. Note, for example, *Gothic Trees*. Even though these trees were actually seen shaped like this, you can't help but think the artist was carried away.

Gothic Trees

CHAPTER 23
Studio painting

My preference for carrying a studio around with me in a car doesn't rule out the need for painting in a larger, well-established work area as well. My studio, which I share with my wife (she is also an artist) is a fine, big room with excellent north light.

When developing some of the half sheet paintings into full sheet watercolors I work in the studio. A slide projector is a great help when doing this. It's hard to make a larger scale drawing without using a projection device of some type. Of course, you can use the squared-off method of enlarging your painting if you have no projector. But this procedure takes much more time; time that can be used more profitably in painting.

When I have completed about thirty half sheet paintings, I usually call in a professional photographer and have him shoot one whole roll of color film. This gives me a record of the paintings and also enables me to use the slide in the projector and enlarge it to a full sheet size if desired. After selecting the slide of the painting to be enlarged, I project the image onto a full sheet of watercolor paper and begin tracing the design for the new, larger painting. Painting the subject a larger size is more difficult, and usually takes much longer to do than the original small-sized painting. Obviously it can be more pleasant working in the studio than on location. You should feel comfortable working both ways.

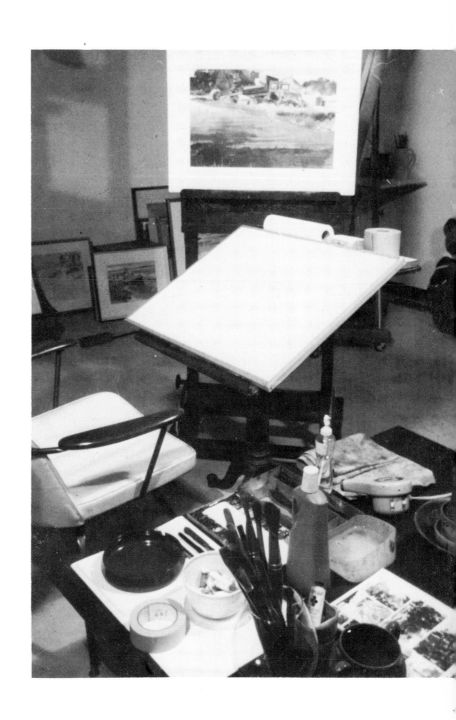

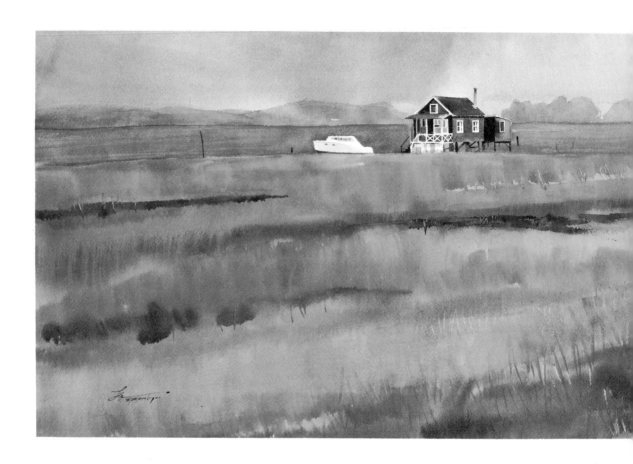

CONCLUSION

It has been my hope in these pages to convey the joys of painting in what many consider a difficult medium. Surely everyone who works with watercolor encounters moments of anguish, despair and torment. The vicissitudes of the medium can be as fickle as they are uncompromising. What a satisfaction to fight one through and win. As the old precept puts it, "Virtue is its own reward." Or, as Fred Gettings in his book, *Techniques of Drawing,* describes it, "You need seek no further justification for drawing than the actual *enjoyment of drawing.*"

If you practice this philosophy, a natural by-product of your efforts will likely be a number of material rewards, in addition to your own sense of accomplishment and fulfillment. Remember, the painter exploits the natural union of the eye, the brain and the hand. When they all come together in a meaningful unit, you know you have achieved something lasting and worthwhile. May you exploit these qualities to their fullest in the days and years ahead!

BIBLIOGRAPHY

Andrew Wyeth, David McCord New York Graphics
 Society, Greenwich, Ct.
The Artistic Anatomy of Trees, Rex Vicat Cole,
 Dover Publications, Inc., New York
The Art Spirit Robert Henri, J. B. Lippincott Co.,
 New York
Contemporary Chinese Painting, Lubor Hájek,
 Adolf Hoffmeister, Eva Rychterová Spring
 Books, London
Drawing Outdoors, Henry C. Pitz, Watson Guptill,
 New York
Flower Painting in Watercolor, Charles Reid,
 Watson Guptill, New York
The Many Ways of Water & Color, Leonard
 Brooks, North Light, Westport, Ct.
On the Art of Drawing, Robert Fawcett, Watson
 Guptill, New York
Starting with Watercolour, Rowland Hilder,
 Watson Guptill, New York
Techniques of Drawing, Fred Gettings, Viking
 Press, New York
Watercolor—The Creative Experience, Barbara
 Nechis, North Light, Westport, Ct.
Watercolor with O'Hara, Eliot O'Hara, G. P.
 Putnam's Sons, New York
The Watercolors of Dong Kingman, Alan D.
 Gruskin, Studio Publications, New York &
 London
The Winning Ways of Watercolor, Rex Brandt, Van
 Nostrand Reinhold, New York
Winslow Homer at Prout's Neck, Philip C. Beam,
 Little Brown & Co., Boston